&

Pink Flamingos & the Yellow Pages

The Stories behind the Colors of Our World

Bob Hambly

CHRONICLE BOOKS

SAN FRANCISCO

For Barb and Emma

Library of Congress Cataloging-in-Publication Data:
Names: Hambly, Bob, author.
Title: Pink flamingos & The yellow pages : the stories behind the colors of our world / Bob Hambly.
Other titles: Pink flamingos and The yellow pages : the stories behind the colors of our world
Description: San Francisco : Chronicle Books, [2021] | Includes bibliographical references. |
 Identifiers: LCCN 2021031510 (print) | LCCN 2021031511 (ebook) | ISBN 9781452180496
 (hardcover) | ISBN 9781452180618 (ebook)
Subjects: LCSH: Color in design—Miscellanea.
Classification: LCC NK1548 .H355 2021 (print) | LCC NK1548 (ebook) | DDC 701/.85—dc23
LC record available at https://lccn.loc.gov/2021031510
LC ebook record available at https://lccn.loc.gov/2021031511

Manufactured in China.

MIX
Paper from
responsible sources
FSC™ C169962

Design by Allison Weiner.
Typesetting by Frank Brayton.
Typeset in Graphik.

10 9 8 7 6 5 4 3 2 1

Chronicle books and gifts are available at special quantity discounts to corporations, professional associations, literacy programs, and other organizations. For details and discount information, please contact our premiums department at corporatesales@chroniclebooks.com or at 1-800-759-0190.

Chronicle Books LLC
680 Second Street
San Francisco, California 94107
www.chroniclebooks.com

introduction

When I was a kid, the last week of summer meant one thing: Mom was taking us shopping. A new school year was beckoning, and my sister, brother, and I needed to be prepared. Clothes topped the list, but the best part of the day was loading up on school supplies. I'd search out a crisp-edged alphabetical stencil sheet and a drawing set complete with compass and protractor. Without a doubt, though, my most prized purchase was a pristine box of Laurentien Pencil Crayons—the twelve-pack.

The package design is etched in my memory. Below the drawing of a cozy chalet, nestled in a snowy landscape, sits an oval-shaped infographic highlighting the sharpened ends of two pencils. One depicts the point of an "Ordinary Lead"—it's tiny and sheepish. The other, the "Laurentien Lead," is nothing less than brazen—a pencil anxious to leave

its mark. Once home, I'd sharpen the wooden crayons, gradually revealing their core values, and return them to the box in their original rainbow sequence.

Over time, the pack of twelve became a pack of twenty-four, then thirty-six. When I graduated from colored pencils to markers, the cardboard boxes gave way to thin metal cases housing sets of forty-eight and sixty-four colors. Markers led to paint—watercolor, acrylic, gouache, and oil. Infinite possibilities lay before me, my palette no longer limited to a single pencil or pen. At art school I was introduced to Color-aid, a collection of individual sheets of colored paper: 314 unique hues silkscreened in a rich chalky finish. We experimented with these papers in a color theory class, exploring the unforeseen relationships that emerged. This is the very same color paper system used by Josef

Albers, the Bauhaus-trained artist and professor whose knowledge of color is legendary.

All of this has honed my understanding of color, impacting my decisions as an artist and designer. I realized years ago that color is a never-ending study. Fine art, design, nature, literature, history, and sociology are forever expanding my appreciation of the subject. It may be the surprise of discovering how a booby's blue feet help it attract a mate or why a color can have a starring role in a movie. This book is a collection of my favorite stories about color. I hope they bring you a sense of joy similar to the one I experienced as a kid, drawing with my coveted colored pencils.

color of the year

SINCE IT WAS FIRST introduced in 2000, the color of the year has included Radiant Orchid, Living Coral, and Tangerine Tango. All captivating names. All easy on the eyes. But how does a particular color rise above the others to warrant top billing? And who makes a decision like this?

Officially, the chosen color is referred to as the Pantone Color of the Year, named after the U.S. firm that determines and promotes the yearly selection. The Pantone Matching System (PMS) is the premier resource designers use to maintain color consistency. PMS color standards are invaluable for many professions, including graphic design, industrial design, automotive design, fashion, and home furnishings. All design studios have Pantone color books with their vast selection of clearly organized, removable color chips.

Choosing the color of the year is an extremely involved process. Consultants visit major fashion centers like London, Paris, and Milan and then report on new color directions showing up on the runways. They scrutinize motion pictures, the art world, and new technologies for clues to rising trends. And let's not forget flora and fauna, which present new and interesting color variations and combinations to consider. Notes, photographs, interviews, and constant observation inform the selection committee's investigation. In the end, the color of the year may not resonate with you personally, but you can be sure a thorough and adventurous journey led to the final outcome.

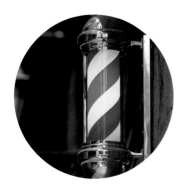

barber poles

THE ICONIC STRIPED BARBER pole's symbolism goes back centuries. Before the 1500s, barbers performed many services for the public, not just the cutting and shaving of hair. Barbers would remove lice from scalps, pull teeth, and perform minor surgeries like bloodletting. Yes, bloodletting. Draining one's body of blood was an ancient method meant to keep body fluids, or "humors," in balance. A barber pole is an amalgam of symbols derived from the procedure. Let's take a closer look.

The brass ball atop a classic barber pole represents the vessel used to capture a patient's drained blood. The pole itself is symbolic of a rod that patients would firmly grip in their hand to expose their veins to the barber. The alternating stripes on the pole signify the bandages used during a bloodletting procedure—white for clean ones and red for the blood-soaked aftermath. Postoperative bandages, once washed, were hung out to dry on a pole, where they would invariably twist together in the breeze—hence the red-and-white spiral motif.

Some barber poles consist of red and white stripes but many, especially in North America, are tricolored—red, white, and blue. There are several theories behind the addition of blue to the design. One story says it represents a person's bluish veins, another posits that blue joined the mix when barber poles came to the United States—echoing the colors of the Stars and Stripes. No one knows for sure. Personally, I like the blue vein story.

So the next time you're visiting a barbershop, ask about the bloodletting services that they advertise and see what kind of response you get.

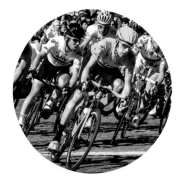

yellow jersey

THE WORLD'S PREMIER CYCLING event, the Tour de France, has been entertaining racing enthusiasts since 1903. In the early years of the race, the cyclist with the overall best time wore a green armband. However, as the number of competitors grew, it became increasingly hard for spectators and journalists to spot the leader among all of the racers. In 1919 the founder of the tour, Henri Desgrange, came up with a clever idea: He made the stage leader wear a bright yellow jersey. Desgrange knew this would accomplish two goals—it would make the lead rider highly visible, and it would help promote *L'Auto*, the newspaper that sponsored the Tour de France. At the time, *L'Auto* was known for the yellow-colored paper that it was printed on. This is an early example of cross-marketing.

The yellow jersey—or as the French say, the *maillot jaune*—was an instant success. The Tour de France has since added a green jersey for best sprinter, a white jersey for best young rider, and a polka dot jersey for best hill climber. Belgium's Eddy "The Cannibal" Merckx, who won the Tour de France five times between 1969 and 1974, holds the record for wearing the yellow jersey more than any other rider in the history of the race.

crayon names

IN 2009 CRAYOLA ISSUED a new set of nine crayon colors, to be sold exclusively through Walmart stores. One of the colors was given the name Washer Fluid. The best part about this collection was that they were scented crayons. (Who wants their children playing with a crayon that smells like washer fluid?) The set also contained the intoxicating fragrances Axle Grease (gray) and Engine Oil (maroon).

Crayola is constantly adding and retiring colors in their popular line of waxed crayons. Here are some of the more imaginative monikers that wore out their welcome:

Alien Armpit (yellow green)
Booger Buster (spring green)
Ogre Odor (red orange)
Permanent Geranium Lake (red)
Sasquatch Socks (violet red)
Saw Dust (peach)
Wash the Dog (dandelion)
Woodstock Mud (brown)

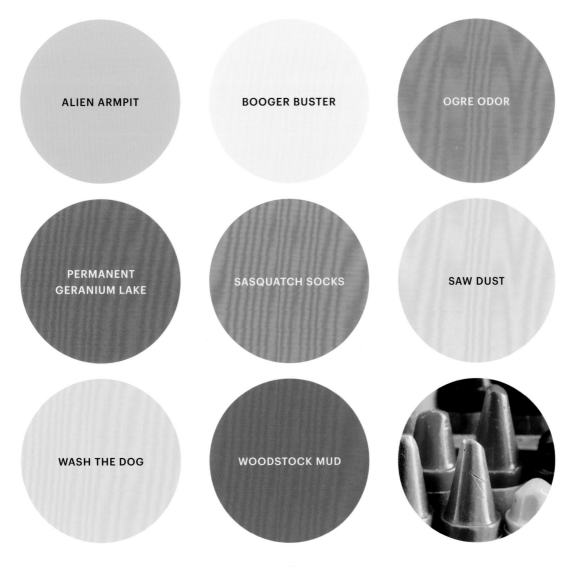

ALIEN ARMPIT

BOOGER BUSTER

OGRE ODOR

PERMANENT
GERANIUM LAKE

SASQUATCH SOCKS

SAW DUST

WASH THE DOG

WOODSTOCK MUD

red-eyed tree frogs

THE RED-EYED TREE FROG is small, never growing larger than 2.75 inches in length. However, what they lack in size they make up for in flamboyancy. Yes, they have prominent red eyes, but they also sport bright orange webbed feet and a neon-green body emblazoned with blue and yellow shapes. These nocturnal creatures sleep under leaves during the day, cleverly hiding all of their colorful parts. If disturbed, they bulge out their red eyes and shock their attacker with a sudden burst of razzle-dazzle as they jump to safety. This defense mechanism is known as "startle coloration," and it gives them precious seconds to escape while a temporary blur of color stuns their foe.

Native to rain forests in Central and South America, red-eyed tree frogs have a life expectancy of around five years. They're becoming popular in North America because they make good pets. Just be careful not to surprise them.

 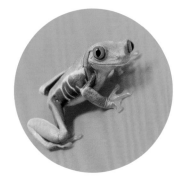

world's
ugliest color

IN 2012 THE AUSTRALIAN government introduced new guidelines for cigarette packaging. Alongside explicit photographs of diseased gums and lung cancer victims is what some people are calling "the world's ugliest color." A research agency isolated Pantone 448 C—a rather sickly shade of green-brown—as a color that proves off-putting to smokers. Market research found that the public associated words such as *dirty, tar,* and *death* with the murky color. Pantone 448 C now covers 25 percent of each and every Australian cigarette package, no matter its size. Since the introduction of the standardized packaging, the number of smokers in Australia has dropped by 118,000, according to a government report. We may never know if Pantone 448 C had an impact on this substantial decline in smokers, but it's safe to say the color is less than appealing.

The color experts at the Pantone Color Institute, who were not consulted during this particular redesign, say there is no such thing as the "ugliest color" nor, for that matter, is there such a thing as the "most beautiful color." It's left up to the individual to make those determinations. I guess the old adage holds true—beauty is in the eye of the beholder.

 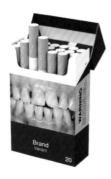

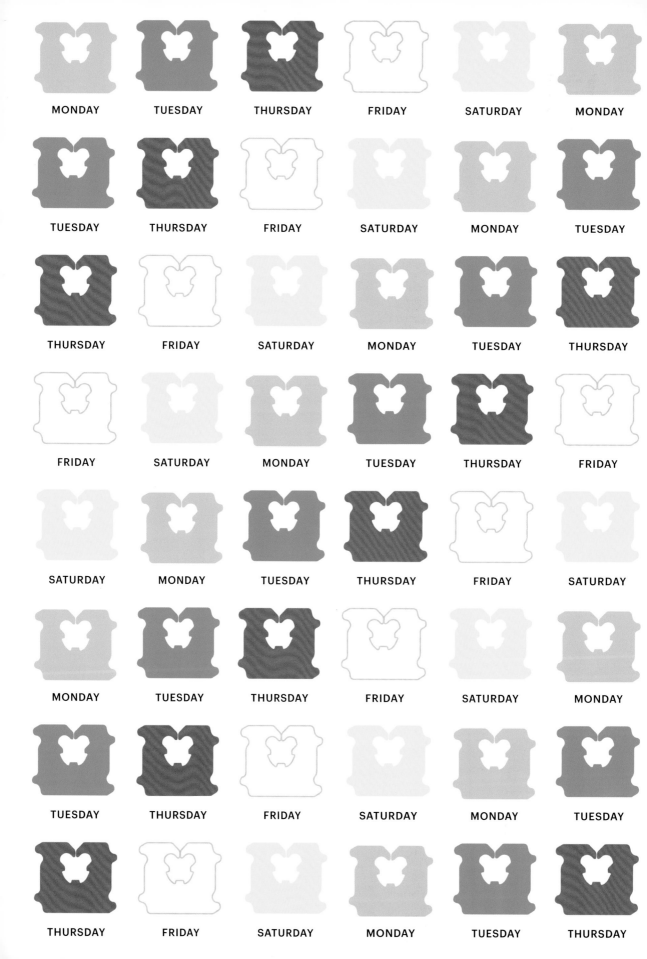

MONDAY

TUESDAY

THURSDAY

FRIDAY

SATURDAY

MONDAY

TUESDAY

THURSDAY

FRIDAY

SATURDAY

MONDAY

TUESDAY

THURSDAY

FRIDAY

SATURDAY

MONDAY

TUESDAY

THURSDAY

FRIDAY

SATURDAY

MONDAY

TUESDAY

THURSDAY

FRIDAY

SATURDAY

MONDAY

TUESDAY

THURSDAY

FRIDAY

SATURDAY

MONDAY

TUESDAY

THURSDAY

FRIDAY

SATURDAY

MONDAY

TUESDAY

THURSDAY

FRIDAY

SATURDAY

MONDAY

TUESDAY

THURSDAY

FRIDAY

SATURDAY

MONDAY

TUESDAY

THURSDAY

plastic
bread tags

THE PLASTIC TAGS THAT keep bread bags airtight are color-coded. As a general rule, the tag's color indicates the day of the week a loaf was baked (see the accompanying chart). Notice that the colors are in alphabetical order B, G, R, W, and Y. A blue tag, therefore, indicates the loaf was baked early in the week; a yellow tag means it was produced on Saturday.

Unfortunately, not all companies implement this specific coding convention. Some use their own custom-colored tags, while others rely on one color for all of their packaging. And to make things even more complicated, there is no tag for Wednesday. Anyway you slice it, bread tag codes are difficult to decipher. More than likely, it's a system designed to help grocery stores manage their stock, rather than inform the consumer.

 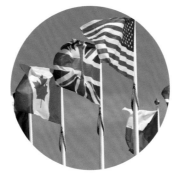

national flags

MANY DIFFERENT COLORS APPEAR in the world's 254 national flags. The most popular color combination used is red, white, and blue. The United States, the United Kingdom, France, Russia, and twenty-seven other nations fly this trio. Countries include red in their flags to represent everything from blood to bravery to revolution. Blue is used to signify, among other things, the sea, the sky, truth, and loyalty. White is a strong symbol of peace, purity, and religion.

One color is rarely found in national flags: purple. Only two countries include it in their palette: Dominica and Nicaragua. In each of these flags you have to look carefully for the color purple; it is used sparingly. There are two main reasons for this. For centuries, purple dye was costly due to the complicated process of producing it. And purple has for ages been associated with royalty; hence people see it as an elitist color. This alone makes it a risky shade for a nation to promote.

greenbacks

PAPER MONEY GOT OFF to a very rocky start in America. Up until the Civil War, the only legal tenders authorized by the federal government were gold and silver coins. That's not to say that paper money didn't exist. Individual banks were issuing their own notes, and by some accounts, there were as many as eight thousand different forms of money. To complicate matters, none of these notes were legal tender, and if a bank went under, their notes became worthless.

There was another equally troublesome problem at this time: counterfeiting. Early banknotes were only printed on one side, using just black ink. Due to a relatively new invention, the camera, money was easy to photograph and copy.

In an effort to finance the Civil War, the U.S. Congress authorized the production of $50 million worth of demand notes, America's first official currency. To prevent counterfeiting, these new notes were printed on both sides, one side with black and green ink, the opposite side just using green ink. The special green ink was made from a patented process originally developed in Canada. It was once thought that the ink's color came, in part, from an unusual source: the leaves of palm trees. As a result of the change in ink color, paper money soon became known as "greenbacks."

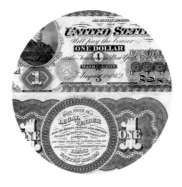

shipping containers

ALTHOUGH SHIPPING CONTAINERS SEEM to have been around forever, they are relatively new to the world of transportation. The sturdy metal units were developed in the late 1950s by a former truck driver who was determined to streamline the shipping and storage of freight, be it by land or by sea. Containers revolutionized the process of loading, unloading, and storing goods being shipped via truck, railway, or ship. These omnipresent corrugated steel boxes come in a multitude of colors. Here are some basic guidelines to understanding the meaning behind the colors.

White and tan indicate new containers that will more than likely be repurposed into storage units or modular structures after serving just one trip. Brown and maroon containers are popular with leasing companies because the dark colors age well, making it easier to sell and trade these containers among different shippers. Bright facades, such as blue, green, red, and orange, represent the brands of the world's largest shipping lines and are therefore most prominent. After a certain amount of time, these colorful containers are auctioned off and repurposed by smaller companies who will add their logos but not necessarily repaint them.

Research has determined that the color of a container can influence its interior atmosphere, especially when exposed to prolonged periods of sunlight. Dark colors tend to absorb the sun's heat and increase both the temperature and the humidity inside the container. Light-colored containers, such as white, gray, and yellow, refract the sun's rays and allow for a somewhat cooler environment within. Temperature and humidity fluctuations during a shipment can have a noticeable impact on certain types of cargo. Who would have imagined that an unsuspected variable such as color could complicate a system that has done so much to standardize the shipping process?

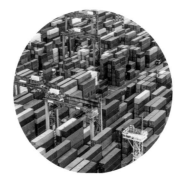

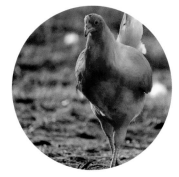

camouflaged chickens

IF YOU ARE A farmer living in Kenya and you are constantly losing a large percentage of your chickens to predatory hawks, what do you do? You've tried everything, but because you are raising free-range poultry, there are limits on how you can protect your flock. The answer? Paint the chickens purple.

Fortunately for the farmers, hawks find this camouflage technique confusing. The hawks do not associate the color purple with chickens and therefore mistake them for a popular ornamental bird that locals keep as pets—a bird that hawks are not interested in. As a result, the hawks ignore the purple chickens. The Kenyan Ministry of Agriculture has authorized the use of an organic, food-based purple dye that does not affect the chicken's meat or eggs.

"I am no longer keeping vigil over the chicks," says farmer Margaret Kimeria. "Previously, it was a task for me to keep watch and scare off the hawks. I want to have as many as I can since managing the chicken on free range is less laborious and there are enough termites for them to feed on. With the chicken dye, I am sure of an intact brood."

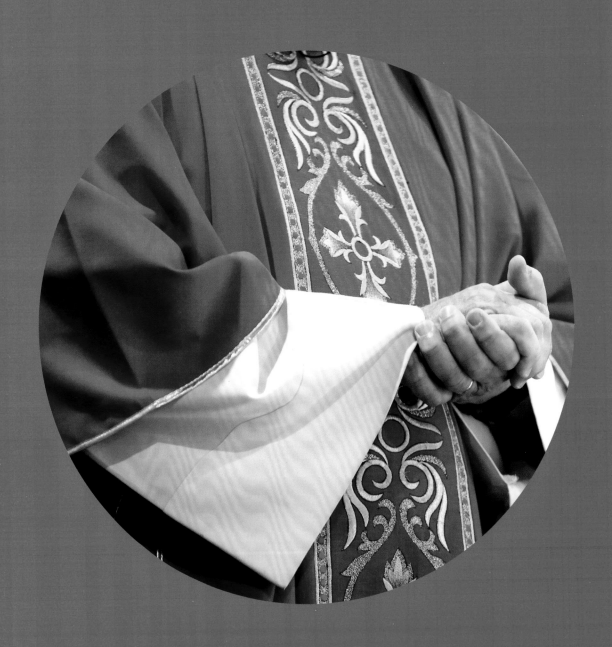

red:
scarlet fever

If you were part of the British Royal Navy in the 1560s, you may have had the great fortune to be recruited into a distinct crew of sailors known as the Sea Dogs.

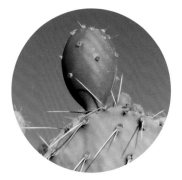

Sanctioned by Queen Elizabeth I, the Sea Dogs were formed to go head-to-head with the other major maritime force of the time: the Armada Española. The Spanish Navy was actively amassing riches from Mexico, filling galleons with the treasures, and shepherding them back home. The Sea Dogs' mission was to neutralize the Spanish powerhouse and to commandeer valuable cargo from their vessels. In other words, if you were a Sea Dog, the Queen had authorized you to be a pirate.

Most sailors jumped at the chance to join this elite corps. Her Majesty's ships were better equipped, the food was more plentiful, and, most importantly, sailors were promised a share of the bounty. Victories at sea led to caches of gold and silver, rare gems, and exotic spices. If you were lucky, the ship's hold would also contain barrels of dead, chalky bugs. These innocuous little creatures, cochineal insects, were equally as valuable as the crates of gold bullion found onboard. The Aztec and Mayan peoples of

Central and North America had been using this bug to dye textiles for centuries, producing a shade of red so intense that the likes of it had never been seen anywhere else in the world. And people back in Europe were clamoring for it.

Cochineal insects live on the prickly pear cactus, feeding off its juices. As a natural deterrent against predators, one quarter of each insect's weight consists of carminic acid, a compound that most animals find unappetizing. The same acid gives the insects a rich scarlet color under their white or gray exterior. The Spanish, realizing the value of the dye to their economy, kept its source a secret for over three hundred years. At the height of production, in the late eighteenth century, one hundred billion cochineal bugs were harvested yearly.

So when the Sea Dogs came across a galleon loaded with dried bugs, naturally they were thrilled. One of the biggest heists ever made on the high seas resulted in the capture of three Spanish

ships carrying a prize cargo of twenty-seven tons of cochineal.

Red. Throughout history it has helped define numerous cultures and empires. It has adorned the textiles, pottery, and bodies of Egyptian, Chinese, Mayan, and Aztec peoples. It symbolizes everything from life, love, and passion to anger, aggression, and victory. During the Renaissance, the robustness of the pigmentation created by the cochineal propelled the color red to even greater prominence. Only those of great means could afford this seductive dye, which meant wearing brilliant red was limited to the aristocracy, royalty, and the church. As cochineal became more readily available, the demand for these distinctive garments increased.

Over time, and with the advent of synthetic dyes in the 1860s, cochineal gradually lost its luster.

The dye produced from the insect faded from international textile markets as it yielded to newer chemical-based technologies. Nonetheless, it is still influential today, finding its way into food, beverages, cosmetics, pharmaceuticals, and paint. Carmine, carminic acid, red dye #40, E120—if you see any of these ingredient names on a product's content list, it contains cochineal.

Back when pigments were relatively few in number and tricky or expensive to produce, along came an unsuspecting little bug that revolutionized the way people created color. Cochineal introduced the world to a new, ultra-desirable, radiant red, setting the bar high for all other colors to match.

Big things do come in small packages.

white house

IN 1814, BRITISH TROOPS invaded Washington, D.C., and set fire to the President's House (as it was known at the time) as well as to other parts of the capital city. The attack was in retaliation for an incident earlier in the War of 1812, when the Americans burned the Ontario Parliament Buildings in Canada. As part of the subsequent repairs, the President's House was painted white to hide the considerable smoke damage—hence the name White House. It's an explanation you may have heard before, but it's wrong. Here's the real story.

Construction of the President's House began in 1792. Eight years later it was ready for its very first occupants, President John Adams and his wife, Abigail. The exterior walls were made with sandstone, and to help seal any cracks or imperfections, a lime-based whitewash was applied atop the porous stone. Rather than allowing the whitewash to weather with time, additional coats were applied to provide further protection. Due to the building's appearance, people started to casually refer to the landmark as the White House. In 1818, after extensive repairs were completed following the British arson, a more permanent coat of lead-based white paint sealed the restoration. One hundred years later, Theodore Roosevelt ordered presidential letterhead engraved with the words WHITE HOUSE – WASHINGTON, making the popular nickname official.

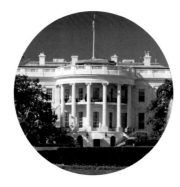

mummy brown

OVER THE AGES, COLOR pigments have been formulated from a wide variety of materials—everything from plants to insects to minerals. Unique colors excite artists and manufacturers about their potential appeal and applications. Arguably, the most unusual source of pigment was actual Egyptian tombs. In the 1800s, finely ground human and feline mummies, combined with special binding agents, produced a complex brown color that was popular with Pre-Raphaelite artists and others. Painters like Eugène Delacroix appreciated how Mummy Brown's transparent quality added a unifying hue to his canvases, enriching both shadows and skin tones.

Trade in Egyptian mummies flourished for centuries. These decomposed bodies were purported to offer medicinal benefits to the living. C. Roberson and Co., a London-based art supply store established in 1810, was selling tubes of Mummy Brown well into the twentieth century. "We might have a few odd limbs lying around somewhere," a company director told *Time* magazine in 1964, "but not enough to make any more paint. We sold our last complete mummy some years ago for, I think, £3. Perhaps we shouldn't have. We certainly can't get any more."

Once the public became aware of the pigment's origin, the color quickly fell from favor. And it didn't help matters that the paint had a tendency to crack and fade over time. It does leave one wondering what circumstances led someone to believe that mummies would make a good pigment, a mystery that may never be unwrapped.

ARCHITECTS
ENGINEERS
MANAGERS

HEAVY MACHINERY OPERATORS
GENERAL CONSTRUCTION

ROAD CREWS
SITE VISITORS

FIREFIGHTERS
EMERGENCY WORKERS

SAFETY INSPECTORS
NEW HIRES

CARPENTERS
ELECTRICIANS
TECHNICAL ADVISORS

WELDERS
HIGH-HEAT WORKERS

SITE VISITORS

 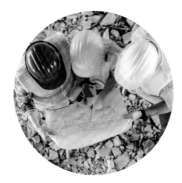

hard hats

A CONSTRUCTION SITE IS often a beehive of activity—trucks, cranes, scaffolding, and building materials of every shape and description. And that's not to mention the many workers buzzing around. Hard hats are mandatory safety equipment for the worksite's entire labor force, regardless of status. The protective headgear has been proven to prevent serious injuries in what can be an accident-prone environment.

But hard hats also serve another, little-known function. Many job sites implement a color-coding system, utilizing each worker's hard hat to designate their particular trade. This highly visible item, worn on the heads of all personnel, makes it easy to identify carpenters, heavy machinery operators, and others from a distance. Opposite is a breakdown of the professions found on a construction site and the hard hat colors associated with each.

Imagine you are a site manager situated several floors above the three workers shown in the photograph. Now, through the aid of color, you have a better idea of their professions and the types of issues they might be reviewing.

kaleidoscope tree

THIS IS THE BARK of the rainbow eucalyptus (*Eucalyptus deglupta*), a tree found in the tropical rain forests of the Philippines, New Guinea, and Indonesia. It's a very fragrant tree that grows to an average height of 230 feet. At different times throughout the year, the bark sheds in strips, revealing a hidden green trunk. Prolonged exposure causes the trunk to change color and creates intense vertical streaks of orange, red, purple, blue, green, and yellow.

The rainbow eucalyptus, also known as the "kaleidoscope tree," produces commercial pulpwood. But although the bark may be multicolored, the pulp it produces is the main ingredient for making pure white paper.

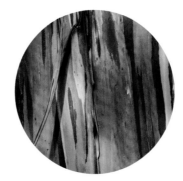

blue
ribbon

BLUE RIBBONS ARE AWARDED at places like horse shows, 4-H competitions, and high schools in recognition of outstanding quality and achievement. But why are they blue? The tradition can be traced back to the sixteenth century, when Henry III of France established l'Ordre des Chevaliers du Saint Esprit (the Order of the Knights of the Holy Spirit). This select cadre was awarded the Cross of the Holy Spirit in recognition of their service and chivalry. The knights became known as les Cordons Bleus (the Blue Ribbons), because the highly prestigious medal hung from a blue ribbon worn around the neck. Over time, the rest of the world adopted this "best of the best" icon, bestowing it to competitors of all descriptions, including a dish made of chicken, ham, and cheese. Blue has always been a meaningful color to the French. It was used as a background to highlight the gold-colored fleurs-de-lis found in the coat of arms of the monarchy and was later incorporated into the country's tricolored national flag.

 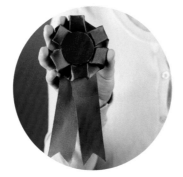

billiard tables

THE GAME OF BILLIARDS has its origins in a fourteenth-century European lawn game. Popular with royalty and the nobility, the game was similar in many ways to croquet. Players hit balls through a series of arches and around pegs with wooden sticks, or "maces," of various shapes and sizes. The outdoor course led to a final target, which players attempted to knock over. Eventually, the pastime moved indoors and was played on a raised table, reducing the amount of time competitors spent hunched over. The table-tops were covered in green felt to mimic the color and texture of the well-groomed lawns of the outdoor version. Wooden sides were added to the tables to prevent the balls from rolling onto the floor.

Nowadays, billiard table felt comes in a variety of colors. People are looking for felt colors that match the interiors of their rooms. Shades of blue, camel, tan, and gray are among the most popular. Billiards, pool, and snooker enthusiasts will tell you that it is extremely difficult to play the game on a table with a brightly colored surface, especially red felt. The color is hard on the eyes and has been known to incite aggression and arguments among competitors, sometimes resulting in physical altercations. It seems only appropriate that the traditional green surface, with its calming effect, remains the favorite of amateurs and professionals alike.

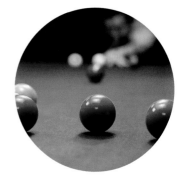

purple prose

THE POPULAR ONLINE RESOURCE Dictionary.com defines *purple prose* as "writing that calls attention to itself because of its obvious use of certain effects, as exaggerated sentiment or pathos, especially in an attempt to enlist or manipulate the reader's sympathies." Let's take a closer look at the origin of this expression.

Purple dye goes back to ancient times. It was originally produced from the secretions of sea snails found in the Mediterranean Sea. It became known as "Tyrian purple," named after the Lebanese coastal city Tyre where the dye was produced. Large amounts of the snail extract are required to make the dye; it takes up to 250,000 snails to yield one ounce. Due to the production process, the much sought-after color remained an expensive commodity for centuries. Until a synthetic dye surfaced in the early 1900s, only royalty and the wealthy could afford clothing dyed with Tyrian purple. As a result, most people considered purple cloth to be ostentatious or excessively ornate. And nowadays, the phrases *purple prose*, *purple patch*, and *purple passage* denote ostentatious or excessively ornate writing.

jewel scarab beetles

INSTEAD OF HAVING A bone structure, certain insects develop an exoskeleton to protect their soft internal tissues. Beetles in the Buprestidae family, also known as "jewel beetles," boast a resplendent metallic armor-like exterior. Their colorful glossy finishes are a result of layers of chitin—a carbohydrate structure made from sugar molecules, similar to cellulose. Chitin is a component of shells for other insects, too, as well as crustaceans like lobsters and shrimp.

Scientists are learning that a scarab beetle's exoskeleton consists of up to seventy individual layers that progressively get thinner as they are added. The transparency of each coating scrambles light wavelengths, causing the light to refract in interesting and different ways. This produces an iridescent metallic effect that, upon first glance, seems entirely unnatural. It is worth noting that metallic automotive paint is also applied in layers, like chitin, creating transparency and light refraction—not to mention strength. Perhaps the next time you see a VW Beetle you will think of it in a new light.

agent orange

DURING THE VIETNAM WAR, the U.S. military used an extremely toxic herbicide called Agent Orange. Under Operation Ranch Hand (1961–1971), more than twenty million gallons of the defoliant was sprayed from airplanes and helicopters over forests and crops in Vietnam, Cambodia, and Laos. The chemical eliminated forest foliage, which increased visibility, and decimated crops, which weakened food supplies.

The actual herbicide is colorless and could not be seen when being deployed. The name Agent Orange originates from the orange stripe that identified the barrels the substance was shipped in. Agent Orange came in a range of strengths; the strongest was called Super Orange. Variations of the herbicide existed, each consisting of different chemical additives that impacted their toxicity. Those other products were named Agents Pink, Green, Purple, White, and Blue.

Production of Agent Orange was finally halted in the early 1970s after scientists learned of the devastating long-term impact that the dioxin traces were having on exposed individuals. To this day, soldiers, civilians, and their families continue to suffer the effects of this harmful chemical. Orange, a color generally associated with happiness, shows its darker side when it comes to the war in Vietnam. The name Agent Orange will forever remind us of horror and destruction.

word origins

vermilion

ver-mil-yuh-n / Latin / 1289

Vermilion comes from the Latin word *vermis* for "worm." There was a popular red dye available in Europe during the thirteenth century that was made from a worm: the *Kermes vermilio*.

amarillo

am-uh-ril-oh / Spanish / 1074

Amarillo is the Spanish word for "yellow." This Texas city is known for the yellow wildflowers that grow around Amarillo Lake and Amarillo Creek—whose shores and banks just happen to have yellow soil.

greenland

green-luhnd / Old Norse / 986

Explorer Erik the Red, a Norwegian-born Icelander, settled on the large island and named it "Groenland" (Greenland). His hope was that an appealing name, one that implied green pastures, would attract other settlers to the remote island.

turquoise

tur-kwoiz / French / 1853

Turquoise comes from the old French word *turqueise*, which means "Turkish stone." Many believe the blue-green semiprecious stone was first brought to Europe from Turkey. Although it's a nice-sounding word, *turquoise* is a misnomer—the stones are originally from Iran.

THE USE OF FLUORESCENT blue lights in public restrooms is gaining momentum in Europe, and it's not because they add to the ambience. The lights make it hard for injection drug users to locate their veins. Under these lighting conditions, it is also difficult to discern white powders, especially on white surfaces. This unconventional lighting feature is being installed in public restrooms in service stations, malls, and retail stores as well as in private bars and nightclubs.

This application of blue lights is controversial. Guidelines published by the U.K. government's Department of Environment, Food, and Rural Affairs (DEFRA) advised that, "due to the increased risks to users and lack of evidence as to its efficiency, blue lighting should not be used in public toilets to deter drug use." According to the Sheriff Court of Edinburgh, Scotland, the blue lights are less of a hindrance than previously thought, for many heroin users are now marking their veins prior to entering blue-lit spaces.

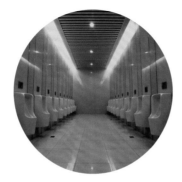

green highway signs

THE NEXT TIME YOU'RE on a highway in the United States or Canada, take a closer look at the information signs you see during your drive. There is a logical rationale for the different colored backgrounds on these signs. Those with urgent messages employ brighter colors: red for stop, orange for construction, and yellow for warnings. Green signs with white lettering impart directional messages—exits, mileage, and mile markers. Blue signs indicate restaurants and rest stops, while brown signs flag areas of outdoor recreation.

Bright colors such as red, orange, and yellow stand out against the landscape and attract our attention quickly. Earth tones such as green, blue,

and brown are common in nature, so signs using these colors are less intrusive to drivers. More importantly, white type on each of these three colored backgrounds reads very clearly at night. The contrast between the colors and the white lettering actually makes the message appear to be larger.

When the automobile was first introduced to North America, there was no standard for road signage. It was not until 1935 that one was established. *The Manual on Uniform Traffic Control Devices* outlined specifications for sign shapes, colors, and typography—setting the foundation for the highway signs we see today.

yellow: defining a decade

I grew up in a house that had a green refrigerator and stove. Or, as my design-savvy mother liked to call the color, avocado. Back then, kitchens in my freshly built neighborhood sported everything from chocolate brown to harvest gold appliances.

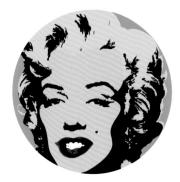

White had become commonplace, while stainless steel finishes were limited to professional restaurants. But one family had a kitchen unlike all the others. When you entered the room, it greeted you like a sunny morning, full of energy and promise. Yellow—a canary yellow—filled the space. In this particular kitchen, the refrigerator, stove, dishwasher, bread box, and sink no longer played a supporting role. They were the stars. This was the 1960s, and bright colors were appearing everywhere. And yellow, taking full advantage of the opportunity, led the way.

For years yellow was relegated to pastel status, used in chintz patterns and on dining-room walls. Now it was commandeering popular culture with unapologetic gusto. The Beatles lived in a Yellow Submarine, Donovan was Mellow Yellow, and summers were all about that Itsy Bitsy Teenie Weenie Yellow Polka Dot Bikini. Pop art, which appropriated everyday images from packaging to comics to celebrities, shocked the art world with its silk-screened

images and enlarged Ben Day printing dots. Yellow illuminated Andy Warhol's Marilyn Monroe portraits and Roy Lichtenstein's enlarged comic strip panels. It reestablished itself as a primary color and a major contributor to the fab four—CMYK, the four inks necessary for printing. Braniff Airways introduced yellow planes, and its flight attendants dressed in wild prints and yellow outfits by renowned Italian fashion designer Emilio Pucci.

Three stylish sports coupes debuted during the sixties: the Chevrolet Camaro, Ford Mustang, and Plymouth Barracuda. All were available in yellow, each designed to win the hearts of young drivers. While on the subject of automobiles, it's worth noting that in 1967 New York City mandated all "medallion taxis" be painted yellow—Dupont M6284, to be exact. Many things conjure up the Big Apple today; the yellow taxi is among the most popular.

And let's not forget the smiley face button. Launched in 1963, it quickly became the

happy-go-lucky symbol of the era. Over a period of ten years, yellow went from bashful to boastful, entering the seventies with a buoyant swagger.

In many respects, the 1960s were a time of awakenings. Cultural and political issues incited protest and debate on topics as varied as war, race, sex, and the environment. It was a time to rebuff conventionalism and explore new horizons, not the least of which was outer space. In many instances, social change proved to be difficult. Yet, regardless of the disruption, a desire for something better continued to flourish. As John Lennon said, "The thing the sixties

did was to show us the possibilities and the responsibilities that we all had. It wasn't the answer. It just gave us a glimpse of the possibility." Changes came in many forms, some monumental, others less so.

The use of color exploded in the 1960s. It became another means by which a generation, newly awakened, could express itself. Young people desperately wanted to be heard and to be seen. They were not interested in being restrained and muted. In the end, it was the brightest color of them all—yellow, a time-honored symbol of hope and enlightenment— that came to define the decade.

cmyk

CMYK IS THE ACRONYM of the four process colors used in color printing: cyan (blue), magenta (pink), yellow, and key (black). Large professional printing presses, as well as small personal laser or inkjet printers, use this color system. In the CMYK process, a sheet of paper passes through four separate rollers, each of which is loaded with one of the process color inks. When laid atop one another in varying degrees of opacity, they fuse together to create full-color images. For example, forest green is a mix of 71 percent C, 1 percent M, 94 percent Y, and 9 percent K.

In a scene from the 2008 Batman movie, *The Dark Knight*, a helicopter lands on the roof of Wayne Enterprises, delivering Bruce Wayne and his female escorts to a gala. Wayne is dressed in black, and the three women are clad in similar dresses—one in pink, one in yellow, and one in blue. Arm in arm, they strut into a room of waiting guests. I like to think that this is movie director Christopher Nolan's way of paying homage to Batman's origins as a comic-book hero, and the CMYK printing process by which the comics were produced.

So much for the Dynamic Duo—this is the Fabulous Foursome.

new
dark ages

A NEW MATERIAL HAS been developed in Britain, and it's so black that it's difficult to understand what you're looking at. The color is made from carbon nanotubes, which can be described as very tiny tubes or straws. These straws are ten thousand times thinner than a human hair. The substance is called Vantablack, and it absorbs up to 99.96 percent of visual light, making it blacker than anything humans have ever known.

To make matters even more astounding, the Indian-born British artist Anish Kapoor acquired exclusive rights to the product in 2016. The licensing of Vantablack to Kapoor is very controversial and has many artists outraged, as they will never get the opportunity to work with the substance. One of Kapoor's first installations incorporating the new material was a piece entitled *Descent into Limbo*, exhibited at Serralves Museum in Portugal. What appears to be a black circle painted on the floor is actually an eight-foot-deep hole whose interior is coated in Vantablack. By eliminating all reflective light, the super-black material presents this particular hole as a two-dimensional shape. Curiosity got the better of a sixty-year-old visitor who, despite posted warnings and a nearby security guard, fell into the void. Fortunately, he was not harmed. Modern art, however, was left with a black mark.

blue lobster

BELIEVE IT OR NOT, blue lobsters really do exist. But your chances of catching an all-blue beauty is one in two million. Their unique color is the result of a genetic mutation that causes an overproduction of certain proteins. Essentially, it's a fluke of nature. Throughout the world, fishermen have reported catching lobsters of other unusual colors: yellow, calico, and albino, all of which are extremely rare. The possibility of netting an albino lobster is estimated to be one in one hundred million. Most of these curious specimens are kept for research in an attempt to better understand the cause of the mutation.

In case you were wondering, the vibrant pigmentation of the blue lobster starts and ends at their shells—so they are safe to eat. And no matter what their color, all lobsters turn red once they've been cooked.

ketchup and mustard theory

HAVE YOU EVER NOTICED how many fast-food restaurant logos use the colors red and yellow? McDonald's, Burger King, Wendy's, In-N-Out Burger, and Hardee's come to mind. This isn't an accident. All colors are infused with meanings that can subconsciously impact our mood, our choices, and how we want to be perceived by others.

Red and yellow are both warm colors that readily attract attention and generate stimulation. Red is vibrant and energetic and tends to cause excitement. It is also highly visible. Because of its brightness, it is the first color that the human eye detects in infancy. Yellow is the color of happiness and youthfulness.

Imagine yourself driving down a street chock-a-block with retail stores and restaurants. Fast-food franchises whose logos incorporate the colors red and yellow will stand out from the crowd. This is known as the ketchup and mustard theory.

These two primary colors, while being uplifting and positive, also promote quick turnover at fast-food restaurants. The presence of red and yellow in any interior does not encourage people to relax and laze about. They are too bold. Brightly colored signs, chairs, tables, and packaging all contribute to keeping us alert and engaged. In other words: eat, enjoy, and move on.

Some say the two colors increase an individual's appetite; however, the research on this subject is mixed at best. One thing is known for sure: blue, the third and remaining primary color, is appetite-suppressing and therefore seldom seen in fast-food establishments. The next time you find yourself at a hamburger joint, see if those iconic ketchup and mustard squeeze bottles remind you of how color helped bring you inside.

green eggs and ham

DR. SEUSS'S *Green Eggs and Ham* was written on a bet. In 1960 the cofounder of Random House, Bennett Cerf, bet Theodor Geisel (Dr. Seuss) that he couldn't write a children's book using fifty or fewer different words. Geisel created *Green Eggs and Ham* using precisely fifty words, and it went on to be his most popular book. To date it has sold over 200 million copies. Despite the book's success, Cerf never made good on the bet.

Green Eggs and Ham, like many of Geisel's books, takes a valuable lesson and wraps it inside a fantastical yarn. The Teaching Children Philosophy website says that *Green Eggs and Ham* "raises the question of the role that experience plays in the formation of our beliefs."

Green, a color generally associated with healthy foods like peas, spinach, and broccoli, becomes the book's catalyst. Eggs and ham that are green suggest something is amiss. This is not the correct color for these foods. Have they gone bad? The story ventures into the realm of irrational prejudice, where decisions are made without actual experience. The food ends up tasting great, regardless of its color.

The way in which food is presented can greatly influence our appetite. Its arrangement on a plate and the color of the plate (most chefs prefer white) are big factors, but so is the color of the food itself. Studies have shown that people respond best to a maximum of four different colors of food on a single plate. But health experts recommend a "rainbow diet"—one that encourages you to eat a wide range of colors, as the spectrum provides all the necessary nutrients. Bring on the green eggs and ham.

 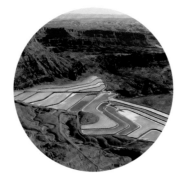

potash ponds

IF YOU HAVE EVER added an all-purpose fertilizer to your garden, chances are it contained potash. The potassium-rich supplement helps plants absorb water, improving, among other things, their taste, texture, and color. But where exactly does potash come from?

The high deserts of Utah are one location rich with the raw material. A manufacturer starts by adding water to the ancient underground deposits that sit thousands of feet below the earth's surface. This creates a brine that is pumped to the surface and settles in large, rubber-lined drying ponds. As the water evaporates, the potash emerges.

At the start of the procedure, workers add a blue dye to the pond to deepen the brine's overall color. This increases the water's darkness, which, in turn, accelerates the evaporation process. During evaporation, the ponds take on an array of colors created by different types and concentrations of algae found in the water. As the salinity levels change, so do the colors of these microorganisms. The ponds progress through a series of gemlike shades of purple, light blue, and sea green. Toffee-colored ponds indicate that the procedure is complete, leaving behind the potassium-rich salt. The mine shown in the photo produces up to a thousand tons of potash every day.

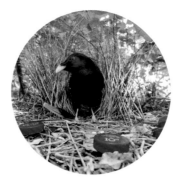

attracting attention

PRETEND FOR A MOMENT that you're a male bird. Your singing voice is ho-hum, your dance moves are less than impressive, and you lack the colorful plumage of a peacock or a mandarin duck. How do you go about attracting the opposite sex? You could take the lead from the bowerbird and create your very own pageant of color.

Native to New Guinea and Australia, bowerbirds are named for the intricate bowers that they construct to attract mates. The structures themselves are architectural wonders: tunnel-like walkways and peak-roofed temples made from twigs and grass. But the icing on the cake is how the bowerbird decorates his handiwork. Inside and outside each structure, the industrious male assembles collections of colorful trinkets. The offerings range from natural objects

such as shells, flowers, berries, and feathers, to scavenged human-made materials like bottle caps, clothespins, coins, straws, and pieces of glass. The flotsam and jetsam are typically arranged in distinct piles according to color. In an effort to enhance their display, bowerbirds will even pilfer objects from neighboring bowers. Boys will be boys.

Scientists have different theories as to why the bowerbird goes to such lengths to attract a mate, but there is no consensus. Researcher Felicity Muth explains in *Scientific American* magazine: "As it has taken evolution millions of years to create this unusual bird and it takes males years to learn how to build the perfect bower, it's not surprising that it will take us humans a bit more time to reveal all the secrets of these avian artists."

sports uniforms

DOES IT MATTER WHAT color jersey your favorite sports team wears? Studies have shown that, in some instances, it does. Researchers analyzed the penalty records of both the NFL and the NHL from 1970 to 1985 and discovered that teams wearing black uniforms were penalized more than any others. Although the studies were not conclusive as to why this occurs, some theories surfaced.

In many cultures, white represents good, and black represents bad. The bad guys in movies typically wear black—think of outlaws, mobsters, and Darth Vader. In English and other languages, words containing *black* often have negative connotations: *blackball*, *blackmail*, *blacklist*, and the *black market*. Are referees more inclined to call penalties against teams wearing black because they subconsciously view them as the "bad guys"? Or perhaps when a player dresses in black, it makes him feel extra tough, encouraging aggressive play. In the case of hockey, black uniforms make players highly visible on the white ice surface, perhaps making them more susceptible to scrutiny.

From the 1990s into the 2000s, despite the findings from this research, more and more teams from the NFL, NHL, and MLB started incorporating the color black into their uniforms. The trend came to be known as BFBS ("black for black's sake"). ESPN had this to say about the phenomenon: "Some teams did it to look more intimidating; some teams did it to sell more jerseys and caps; and some teams just did it because so many other teams were doing it."

However, it seems that the tide is turning and that sports teams are returning to their traditional colors. Professional sports organizations understand the importance of a well-defined brand, one that pays homage to a franchise's past while remaining contemporary. Owners will look to gain a competitive edge wherever possible, and color can play a part in helping them achieve success. Showing a healthy profit is when teams most enjoy being "in the black."

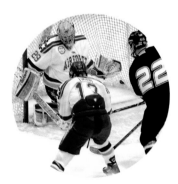

 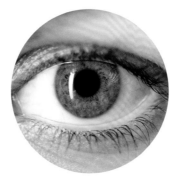

super vision

DID YOU KNOW THAT you are likely a trichromat? It means you have three types of cones in your eyes. As a result, you see about one million distinct tints, shades, and hues. Scientists have recently discovered that 1 percent of the population are tetra-chromats—individuals who have four types of cones in their eyes. Because it takes time for the brain to absorb this additional visual information, tetrachro-mats do not necessarily see any more colors than the rest of us.

However, scientists have identified several tetra-chromats who are capable of seeing the full range of colors that their fourth cone offers. It has been determined that one needs two X chromosomes to see this expanded spectrum, so this unusual dexterity is limited to a percentage of the population. These lucky individuals can discern up to a hundred million colors. That's one hundred times the colors that the rest of us see. The first tetrachromat known to humanity was discovered in Cambridge, England, in 1993, and researchers are working on perfecting a test to identify others who may also have this remark-able "super vision."

Artist Concetta Antico, one of the world's few known tetrachromats, has this to say about her special ability: "Let's take mowed grass. Someone who doesn't have this genetic variation might see bright green, maybe lights or darks in it. I see pinks, reds, oranges, gold in the blades and the tips, and gray-blues and violets and dark greens, browns and emeralds and viridians, limes and many more colors—hundreds of other colors in grass. It's fascinating and mesmerizing."

lucky strike

IN THE SPRING OF 1940 the president of American Tobacco, George Washington Hill, walked into the office of renowned industrial designer Raymond Loewy and set a pack of Lucky Strike cigarettes on his desk. "Someone told me that you could design a better pack," Hill said, "and I don't believe it." Hill bet Loewy $50,000 ($924,000 in 2020 dollars) that he couldn't do it. Loewy, known for his work with Studebaker, Exxon, and Coca-Cola, accepted the challenge.

The designer focused on three areas—he simplified the overall typography, enlarged the Lucky Strike logo, and altered the colors. By switching the predominantly green pack to white, he made the product more appealing to the ever-growing number of female smokers, who now saw a fresher, less masculine package.

When it comes to using color, marketers follow a simple yet important distinction between the sexes (a distinction that is not necessarily based on research). Generally speaking, men like bright colors, and women prefer pastels. Men gravitate to shades of color (where black is added to a pigment), while women prefer tints of color (where white is added to a pigment). Men found the bright red circle of the revised Lucky Strike pack pleasing, while women were drawn to its overall lightness and sophistication.

The redesigned cigarette pack went to market and was an immediate success. Sometimes small adjustments can make a big difference. In this case, Loewy's insights and recommendations on color produced striking results. And Hill, true to his word, paid off the bet in full.

 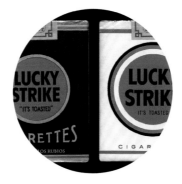

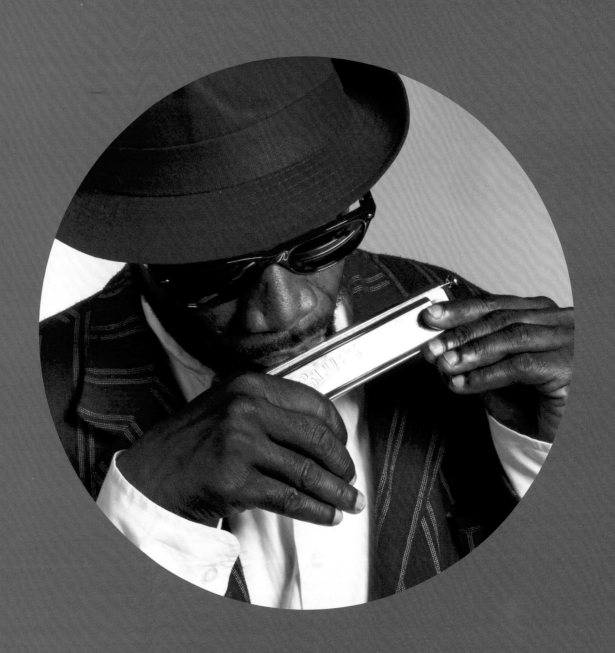

blue:
a source of
inspiration

When I was at art school, my roommate from Charlotte, North Carolina, introduced me to the music of blues harmonica player James Cotton. Soulful and energetic, it was unlike anything I'd ever heard. I was immediately hooked.

The blues is a complex musical genre. Just try explaining it to someone. *The Oxford English Dictionary* defines it as "a style of music, evolved from southern African-American secular songs and usually distinguished by a syncopated 4/4 rhythm, flatted thirds and sevenths, a 12-bar structure and lyrics in a three-line stanza in which the second line repeats the first." It's a thorough definition, to be sure, but something is missing. It doesn't quite get to the heart of the blues.

Blues music means different things to different people, and seeing as there are many forms, from gospel to boogie-woogie, getting at its essence can be challenging. Here's what three musicians have to say on the subject. The Father of the Blues, W. C. Handy, said the blues is "the sound of a sinner on revival day." Legendary vocalist Alberta Hunter said, "We sing the blues because our hearts have been hurt, our souls have been disturbed." But perhaps B. B. King, the celebrated blues guitarist, said

it best when he observed, "People all over the world have problems and as long as they have problems, the blues can never die."

A reoccurring theme of forlornness and struggle emerges in many descriptions of the blues. But it still doesn't explain the connection to the color. So how did term *the blues* come about?

Blues music grew out of the hymns and spirituals brought to America by enslaved Africans. Their strong oral culture relayed profound personal experiences from generation to generation, in large part through music and song. The oppression slaves suffered at the hands of tyrants gave them good reason to voice their struggle, but the term *the blues* refers to an entirely different demon: alcohol.

Throughout history, various cultures—including the Greeks, Romans, Chinese, and Egyptians—believed that sicknesses of the mind were caused by demons. In England, the term *blue devil* surfaced during Elizabethan times to express the visions one

has while undergoing alcohol withdrawal. With delirium tremens, or the DTs, came melancholia, tremors, and often hallucinations. If the "blue devil" came knocking, it meant one had slipped into a state of overwhelming depression. Eventually, the phrase was shortened to *the blues*.

Washington Irving, best known for his short story "The Legend of Sleepy Hollow," is credited as the first American author to use *the blues* as a synonym for sadness. In 1807, the following sentence appeared in Irving's satirical publication *Salmagundi*: "My friend Launcelot concluded his harangue with a sigh, and I saw he was still under the influence of a whole legion of the blues."

The color blue can also be incredibly uplifting. It's the color of oceans and the sky, suggesting

expansiveness, openness, freedom, and imagination. There's the wild blue yonder and blue-sky thinking. Blue represents wisdom, honesty, and trust: true blue. Throughout the world, blue is the most favored color of them all; regardless of people's gender, country, or cultural background. Blue can be found in 53 percent of national flags and is a prominent color used in corporate branding. Rooms painted blue tend to help improve people's creativity and productivity.

Yet blue is the color we use to describe sadness and depression. Blue resides at both ends of the emotional spectrum, taking us from the height of creativity to the depths of despair—a mercurial color, if ever there was one. Maybe that explains why musicians often say that having the blues is their greatest source of inspiration.

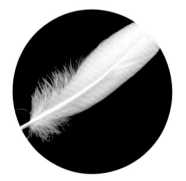

white feather

NOT LONG AFTER THE start of the First World War, it became a common occurrence in Britain for a woman to approach a young man not in uniform and present him with a white feather. As a symbol of cowardice, the white feather is said to have its origin in cockfighting. (Apparently, white-feathered roosters are poor fighters.) Started by avid war supporter Admiral Charles Fitzgerald, the White Feather Brigade's mission was to publicly humiliate men who had not enlisted. Before long, this form of public shaming spread to other parts of the British Empire.

There are many recorded incidents of servicemen mistakenly receiving white feathers while home on leave and out of uniform. Other recipients, who had been deemed unfit for war, were traumatized by the public shaming. Made to feel emasculated and disgraced, some even committed suicide.

In warfare, the color white indicates passiveness; white flags, for example, signal neutrality, surrender, and peace. When you add to the mix the color's association with purity and innocence, it can make for a powerful badge of shame during times of armed conflict.

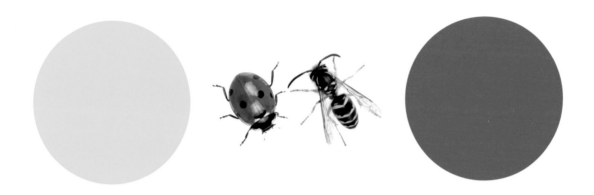

nature's warning signs

CERTAIN MEMBERS OF THE animal kingdom will go out of their way to inform others that they pose a threat. Some accomplish this through color. This characteristic is called "aposematism," a term introduced in 1890 by English zoologist Edward Bagnall Poulton. The word, as defined by *The Merriam-Webster Dictionary*, means "the use of a signal and especially a visual signal of conspicuous markings or bright colors by an animal to warn predators that it is toxic or distasteful." *Aposematism* is derived from the Greek words *apo*, meaning "away," and *sema*, meaning "sign."

Take, for example, the skunk—its broad white stripe reminds others not to get too close, or else. The yellow-banded poison dart frog's graphic colors warn of the toxins its skin excretes. A wasp uses the same colors to signal a potential sting. And the brighter the ladybug, the more toxic it is. Studies show that white, yellow, red, and black are the most effective warning colors that animals brandish. In the same manner that traffic signs caution motorists, colorful animal markings are nature's way of saying, "Watch Out!"

passports

UNTIL RECENTLY, PASSPORTS THROUGHOUT the world were issued in just four different colors: blue, red, green, and black. There are no official guidelines for how a nation determines the color of its passport. However, some general trends are evident. Blue tends to be used by newer countries (founded after 1770) like Canada, the United States, Australia, and Hong Kong. Red is found predominantly in Eastern Europe and Asia, especially in countries established after 1920. Green is popular with nations that have large Islamic populations on account of its religious significance (it was a favorite color of the prophet Muhammad, symbolizing nature and life). Black is used by the fewest nations, among them Angola, Chad, and New Zealand. Burgundy has become the passport color for nations that are part of the European Union.

Thankfully, contemporary passport design is less conventional. Countries like Canada, Norway, and Switzerland are saying farewell to traditional passport layouts and producing new and exciting documents. Norway's passport has three different cover color options: salmon pink, robin's-egg blue, and white. Switzerland has added a handsome pattern of debossed crosses to its scarlet red cover. But that's just the start. The real changes are occurring between the covers—full-color pages, stylized illustrations, and images that only appear under black lights. Finland's passport acts as a flipbook, showing an elk walking through the pages.

As with world currency, countries are seeing the value of well-designed passports. Unconventional graphics and printing techniques accomplish two objectives: passports become harder to counterfeit, and they better reflect a country's unique identity. Look for new innovations as the world of passport design becomes less formulaic and more expressive.

yellow pages

THE YEAR IS 1883, and Reuben H. Donnelley is busy printing a telephone directory in Cheyenne, Wyoming. At some point during the production, the supply of white paper runs out. Knowing that a new shipment will take weeks to be delivered, Reuben opts to finish the job using the only other stock available in the shop—and it's yellow.

People react positively to the color, commenting on how easy it is to spot a yellow directory among all of the white-papered publications. Subsequent studies prove that black type atop yellow paper is easier on the eyes than black on white paper. Three years later Donnelley creates the first official Yellow Pages directory, and it's an immediate hit. Editions of the Yellow Pages start popping up throughout the world.

The Yellow Pages made sourcing businesses an easy task. Their catchy slogan, "Let your fingers do the walking," introduced in 1964, became a common catchphrase. The internet, however, has caused the gradual decline of the once-popular directory, with fewer and fewer being printed each year. It was recently announced that, after fifty-one years of connecting people to services, the United Kingdom Yellow Pages will say goodbye.

clay tennis courts

THE GAME OF TENNIS is mainly played on one of three surfaces. The most popular is hard court, and the majority of tennis enthusiasts, professional or amateur, play on this substance. The two remaining court surfaces are grass and clay. Of the four Grand Slam tennis tournaments, two are played on hard courts (the Australian Open and the U.S. Open), one on grass (Wimbledon), and one on clay (the French Open). Tennis players will tell you that a clay surface is the most challenging to play on. Let's look deeper at clay courts.

There are very few courts in the world actually made from real clay. Back in the late 1800s, seven-time Wimbledon champion William Renshaw sprinkled a thin layer of red powder over his tennis court to prevent the grass from being burnt by the sun. The organizers of the French Open followed suit, using broken terra-cotta pots as a playing surface. A modern clay court has a solid base made of limestone and sand and is covered in a layer of finely crushed red-orange brick.

The courts of the French Open go through eighty-eight thousand pounds of the material each year. Preparing the court for a match means that groundskeepers spend hours raking, rolling, and dampening the brick. During a typical tennis match, the brick coating will become chalky, amass in certain areas, dissipate into the air, and stick to clothing. To make necessary repairs to the courts, a stockpile of eleven thousand pounds of freshly crushed brick is close at hand to ensure the "clay" courts are always dressed in their best red. Advantage—French Open.

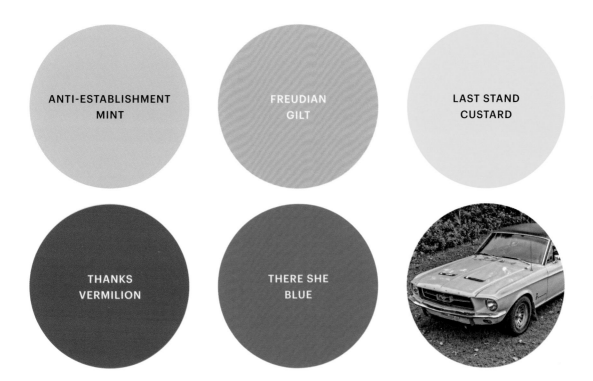

ANTI-ESTABLISHMENT MINT

FREUDIAN GILT

LAST STAND CUSTARD

THANKS VERMILION

THERE SHE BLUE

groovy car colors

FROM 1969 TO 1970 the Ford Motor Company, in an effort to appeal to a younger and more mobile audience, offered many of their sportier models in paint colors with playful names. Mavericks, Mustangs, Pintos, and other models came in colors with names that reflected the mood and language of the times. Remember, this was back when people were listening to groups like Strawberry Alarm Clock, watching *Laugh-In* on television, and going to the movies to see *Easy Rider*. Here are some of the groovy names the automaker coined:

Anti-Establishment Mint (mint green)
Bring 'em Back Olive (olive green)
Freudian Gilt (gold)
Last Stand Custard (bright yellow)
Original Cinnamon (burnt orange)
Thanks Vermillion (deep red)
There She Blue (medium blue)

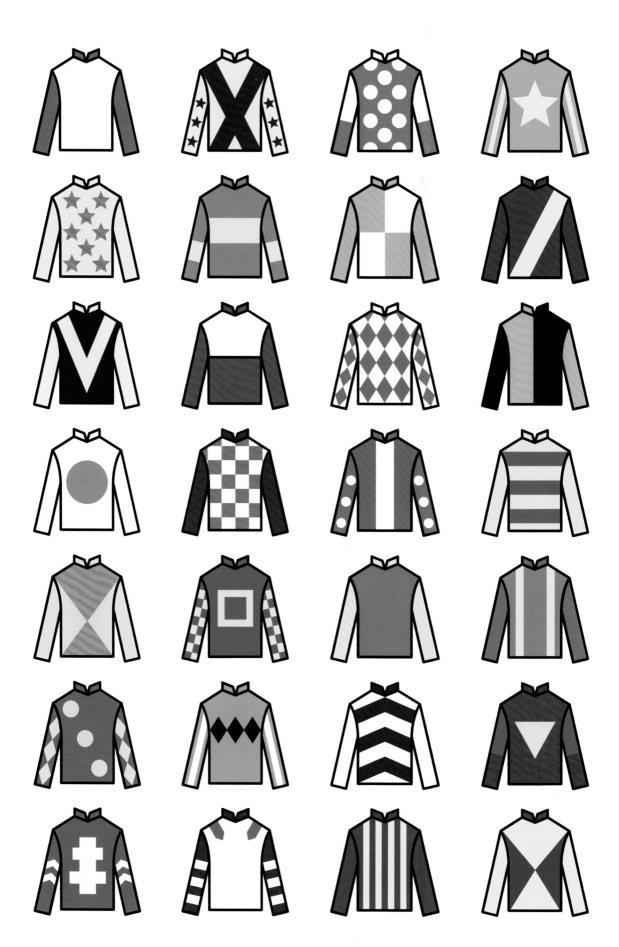

jockey silks

MULTICOLORED JACKETS ADORNED WITH bold stripes, polka dots, checkerboards, stars, or shamrocks—these outfits look like they belong in the circus, not on the racetrack. Each jockey wears a uniquely designed uniform, one that will help spectators follow their favorite horse as it speeds around the circuit. The official name for the festive outfits is "racing silks," and they have been part of the sport for over 275 years.

By the mid-1700s, horse racing had become a popular pastime in Great Britain. As enthusiasm grew for the sport, so did the number of horses participating in each race. The British Jockey Club made it mandatory for jockeys to wear distinct colors so that it was easier to identify the entrants. Jockey silks were initially made from solid-colored, lightweight silk. As the number of registered owners and horses multiplied, patterns and color combinations were introduced into the designs. Traditional family crests and insignias helped add personality to the jockey's garb.

Today in the United States and the United Kingdom, each horse owner or stable must register their designs so that no two racing silks will be the same. Between the two countries there are a total of thirty-one thousand registered silks. In America, one must adhere to strict guidelines when designing a new racing silk. The front and back must display identical designs. To establish some semblance of order, the Jockey Club provides thirty-eight patterns to choose from. For additional customization, nineteen different sleeve patterns are available. Racing silks are limited to a total of four colors, two each for the jacket and the sleeves. Nowadays, silk is seldom used to craft the garment; nylon or a Lycra/polyester blend are the preferred fabrics. And in the United Kingdom, when a jockey is given new silks, the tradition is to throw them on the ground and stamp on them. They say it's best that they hit the ground, so the jockey doesn't.

word origins

baton rouge

bat-n roozh / French / 1682

Baton Rouge, the capital of Louisiana, is a city on the Mississippi River. In 1682 French explorer René-Robert Cavelier (La Salle) spotted a prominent cypress tree that had been stripped of its bark, making the tree appear red in color. The Frenchman referred to the tree, which was used by local Indigenous tribes to demarcate hunting grounds, as *le baton rouge*—French for "the red stick."

argentina

ahr-juhn-tee-nuh / Spanish / 1853

The name Argentina comes from the Latin term *argentum*, which means "silver." It dates back to a time when shipwrecked Spanish conquerors were given silver objects of trade by the Indigenous peoples. News of the legendary Sierra del Plata, a mountain rich in silver, reached Spain in 1584.

khaki

kak-ee / Urdu / 1855–1860

Khaki is the Urdu word for "dust." The name was introduced into the English language via the British Indian Army. Over the years, British forces gradually eliminated their classic scarlet tunics for something more suitable for camouflage. In India they adopted uniforms the color of sand, giving us the ever-popular khaki pants.

fuchsia

fyoo-shuh / Modern Latin / 1745

Fuchsia takes its name from the fuchsia plant, which was in turn named after the sixteenth-century German botanist Leonhard Fuchs. Fuchsia became popular as a color in 1859 after a French chemist patented a new aniline dye called "fuchsin." Fuchsin's vivid purplish-red color was used primarily to dye textiles.

a small generator. The device contains two main components: a flight-data recorder (FDR) and a cockpit voice recorder (CVR). After a crash, these two recorders provide investigators with both logistics—airspeed, altitude, rudder position, etc.—and flight cabin conversations. The black box is typically situated in the tail section of the aircraft, a location with a high likelihood of surviving a crash. The device's bright orange coloring makes it easier to locate.

There are several explanations for the term's origins, but most likely it comes from the black metal box that covered the device when it was first used in Royal Air Force bombers during World War II. The box was painted matte black to prevent it from giving off reflections. The term *black box* is now broadly used for mechanisms that obscure information.

 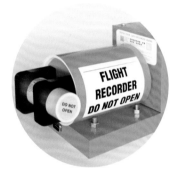

 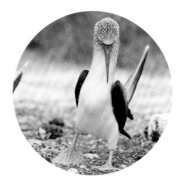

blue-footed booby

WHEN A FEMALE BLUE-FOOTED booby goes on a search for the perfect mate, she is looking for something very specific. She's not concerned about how tall her suitor is or how strong his mating call may be. She's focusing on his feet. And it's the males with the brightest blue feet that she finds the most attractive. The blue pigmentation comes from the marine bird's diet of fresh ocean fish such as anchovies, mackerel, and sardines. The carotenoids that these fish provide directly impact the color of the booby's feet. The bluer the feet, the healthier the bird. Thus they are a vivid barometer of a male's level of nourishment. Studies have shown that healthy males make for caring fathers by actively contributing to a chick's

upbringing. In addition, their big blue feet keep eggs warm during the gestation period.

This brings us to the mating process. Male blue-footed boobies put on quite a show. They extend their wings, confidently point their heads back, lift their beaks to the sky, and proceed to brandish their webbed feet, one blue foot at a time. The high-stepping booby continues to show off his wares until the female accepts him. This slaphappy routine is where the bird gets its name. It is derived from the Spanish word *bobo*, meaning "stupid" or "foolish." Despite how silly the dance looks, it gets the job done. Sometimes unusually effective ideas come right out of the blue.

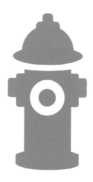

1,500 GPM
VERY GOOD FLOW

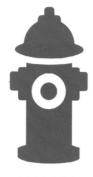

1,000 GPM
GOOD FOR RESIDENTIAL
AREAS

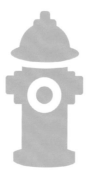

500–999 GPM
MARGINALLY ADEQUATE

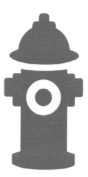

BELOW 500 GPM
INADEQUATE

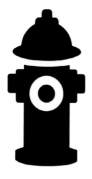

OUT OF OPERATION

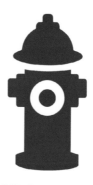

LAKE OR POND WATER

fire hydrants

YOU MAY HAVE NOTICED that not all fire hydrants are the same color. Their appearance is not arbitrary; in fact, it's part of an intentional color-coding system. Municipalities use it to inform firefighters of the water capacity available at each hydrant location. The different colors indicate gallons per minute (GPMs). The higher the GPMs, the more water there is to fight fires with.

But this system can get confusing. When you come across a two-toned fire hydrant in the United States, the cap color signals the unit's GPM, and the body indicates the ownership and/or usages of the water. For instance, white bodies mean the hydrant is part of the public water system, yellow bodies are for private hydrants connected to public water, and violet bodies signify water that comes from a pond or lake. A fire hydrant painted black means the unit is out of operation. To further complicate things, only about half of the fire hydrants in the country follow the code. Some regions have opted to use unique color codes for their specific requirements. Although color coding is used by many countries worldwide, no one standard is being followed. So you'd best get permission before painting your neighborhood fire hydrant to look like Super Mario or Uncle Sam.

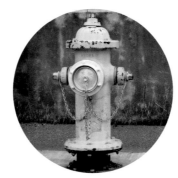

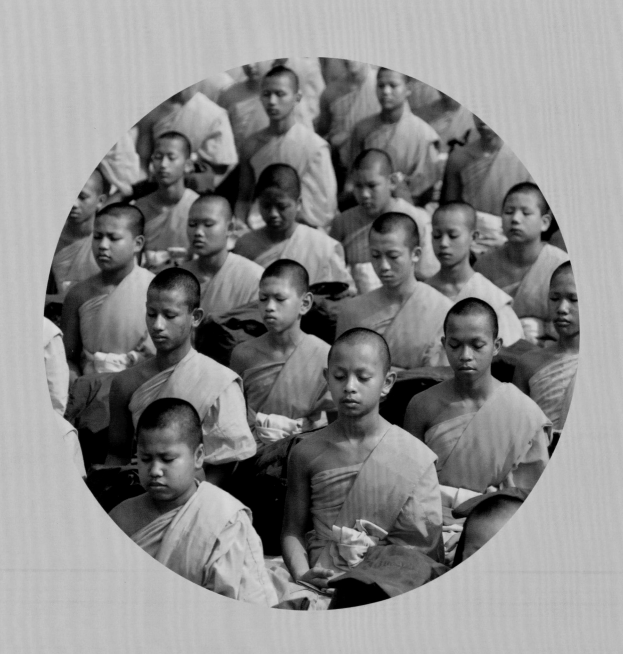

orange:
maintaining
uniformity

The young monks pay close attention as the elder explains the construction of the monastic robe, because soon they will have to fashion one of their own.

It's estimated that Buddhist monks have been wearing the same basic garment for over twenty-five centuries. The humble robe was once assembled from discarded cloth or scavenged from cremation grounds. But nowadays, monks use fabric donated to Buddhist temples by local residents.

These vestments consist of a series of stitched-together rectangular shapes that duplicate the dimensions of a typical rice field. Each monk will craft three separate components: an inner robe that covers the body between the waist and the knees, an upper robe that hangs from the shoulders, and a double-layered outer robe to be used on special occasions. When all three are complete, the novice tailors will discreetly add their name, in calligraphy, to each of the pieces. The robe's simple design is a testament to the monk's devotion to Buddha and a symbolic rejection of the materialistic world. Monks wish to be judged for their spirituality, not for what they look like or what they choose to wear.

Natural materials such as fruits, flowers, leaves, bark, and roots produce the pigments used to dye the raw fabric. Turmeric and annatto seeds are important ingredients in achieving the iconic saffron orange that is synonymous with Southeast Asian Buddhists. The dyeing process generates an exuberant color that symbolizes the radiating energy of the sun, whose flames represent truth and enlightenment.

By wearing identical attire, Buddhist monks deemphasize their individuality, enabling them to concentrate on their common objective of seeking personal spiritual development. Having put aside all the trappings of the outside world, they turn their attention to study and the pursuit of nirvana.

Far from the sacred temples of Asia is another secluded community of individuals where a dress code is mandatory. Inmates within U.S. federal maximum-security penitentiaries wear standard-issue one-piece orange jumpsuits. The short-sleeved, cotton/poly-blend coveralls come in a variety of

 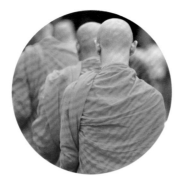

sizes and include a heavy-duty elasticized waistband. You will not find zippers, metal snaps, or pockets on these garments. Other than the name of the prison silkscreened in black ink on the back of the jumpsuit, no personal identification is evident.

As with Buddhist robes, this uniform is designed to deindividualize the internees and limit personal expression. But that's where the similarities end. Prison wear does not encourage pride of ownership, nor does it embody a profound message. Orange jumpsuits are used to signal to inmates and guards alike that the wearer is a dangerous person. Like a traffic pylon, the brilliant orange makes the inmates highly visible and easy to track, should they attempt to escape. Lately, lawyers and psychologists have drawn attention to orange prison jumpsuits, warning that they can be demeaning. There is also growing evidence that juries may be predisposed to consider someone guilty who attends a trial dressed in clothing that promotes a stereotype. For both reasons, more somber shades once used in some prisons, like khaki and denim, are making a comeback.

Two entirely different communities linked by a single color. One sequestered by choice, the other by law. One group chooses to dress themselves in orange apparel; the other has it forced upon them. Studies show that people either love the color or hate it. There is no middle ground.

redheads

WHAT DO CLEOPATRA, Queen Elizabeth I, Charles Darwin, and Mark Twain have in common? They were all redheads. Individuals with auburn-colored hair, although they come from many different ethnic backgrounds, represent only 2 percent of the world's population. It will probably come as no surprise that Scotland and Ireland have the highest concentrations of redheads, at 13 percent and 10 percent, respectively.

Sadly, history has been tough on red-haired people. During medieval times they were thought to have supernatural powers and were labeled as witches. The Spanish Inquisition persecuted them because the color of their hair meant they were Jewish. To this day, redheads are portrayed as being everything from mean-tempered to wimpy. Nicknames like "carrot top," "matchstick," and "redheaded monster" don't make life any easier.

Whether strawberry blond or a dark auburn, redheads have numerous characteristics that make them quite alluring. Studies have shown that their skin tends to smell amazing. In his book *The Redhead Encyclopedia*, Stephen Douglas says they emit a "naturally sweet and musk-like scent." German sex researcher Werner Habermehl, after examining the sex lives of hundreds of German women, concluded that redheads have more sex than other women. Research undertaken at Montreal's McGill University showed that redheaded women can withstand 25 percent more pain than blondes and brunettes. To top it off, their hair will never turn gray. It will gradually fade and turn a silvery shade. Now I see why the word *red* sits in the middle of *incredible*.

carpet coral

NO, THESE ARE NOT colorful crocheted tea cozies or hats. They are animals that live in the earth's deep seas and coral reefs. Scientists categorize them as zoanthids, but most people call them "carpet coral," "button polyps," or "zoos." Because they are extremely hardy and electrifyingly vibrant, they are popular with aquarium owners—both hobbyists and professionals. These unique corals spread quickly and typically live in large colonies. Unlike hard coral, they have soft tentacles that resemble the petals of a flower.

Zoanthids do not produce their own pigments; rather, their coloration is determined by the marine algae that live within their tissue. The coral provides protection for the algae, and the algae, with the help of photosynthesis, provide food for the zoanthid. Enthusiasts have learned that they can alter the coral's color intensity by increasing the aquarium's light source, which accelerates the photosynthesis process. Carpet corals come in many varieties and, due to their colorful nature, have playful names. Next time you're at an aquarium supply store, look for Red Devil People Eaters, Orange Bam Bam, Pink Hippos, Nuclear Green, and Purple Space Monsters.

 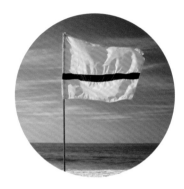

refugee nation

PRESENTLY, AN ESTIMATED SIXTY-FIVE million displaced people are living on the planet Earth. In 2015 a proposal to permanently relocate the world's refugees led to the birth of a movement called Refugee Nation. Governments, industries, and individuals championed the cause and garnered much media attention. The movement also spurred a crowdsourcing campaign to raise revenue.

Yara Said, a Syrian artist, increased public awareness by designing a flag for a group of ten refugee athletes who competed in the 2016 Rio Olympic games. These frustrated competitors had no nation to represent. The flag was inspired by the life vests that Said and other refugees wore as they struggled to survive rough seas during their quest for safe ground. The standard-issue orange life vest, with its single black strap, became an icon that spoke directly to the athletes' struggles. The intense orange fabric, used to make those in peril highly visible, now performs a similar task signifying the Refugee Nation.

red-letter day

A FRIEND ONCE REFERRED to my daughter's graduation from university as a "red-letter day." It's an unusual and memorable phrase, one whose origin goes back hundreds of years. Early Roman calendars indicated important dates with red ink. Holidays and religious observances, like saint's days or feasts, were highlighted to draw the viewer's attention to them. To this day, calendars incorporate this graphic device to differentiate weekends or Sundays, among other dates, from the remaining days of the week. But there is more to the story of red letters.

Before the invention of the printing press, handmade books were created primarily by scribes recording religious stories and wisdom. Monks painstakingly hand-lettered elaborate illuminated manuscripts, complete with detailed illustrations incorporated into the text. While these images were principally decorative, depicting individuals or scenes, they also acted as a guide to the reader.

Prior to the concept of titles or paragraphs, the first letter of the first word of a new section was colored red. As in a calendar, the red letters drew the reader's attention to noteworthy information within a continuous block of text. These areas of emphasis are known as "rubrics," a word derived from the Latin *rubrica*, meaning "red ocher" or "red chalk." In hindsight, seeing as my daughter graduated with a degree in English literature, the expression "red-letter day" was most appropriate.

tin man

THE WIZARD OF OZ, MGM's classic 1939 movie, introduced us to the Scarecrow, the Cowardly Lion, and the Tin Man. The three lovable characters join Dorothy Gale in her quest to find the all-knowing Wizard of Oz, the one person with the power to send her back home to Kansas.

Jack Haley played the role of the Tin Man, but he was not the studio's first choice for the part. Buddy Ebsen, who went on to fame as Jed Clampett on the hit 1960s TV show *The Beverly Hillbillies*, was originally hired to play the character. After four weeks of rehearsing, song recording, and costume fitting, the filming of the movie began. But nine days into the production, Ebsen became ill, complaining of cramps and shortness of breath. He eventually went to the hospital, where he spent two weeks recuperating. Doctors discovered that the aluminum dust used in his silver face makeup had entered his lungs, causing his illness. Ebsen had to abandon the movie project, and Jack Haley took over the role. This time around, with the help of safe silver makeup, the Tin Man experienced no side effects.

Twenty-five years later, metallic paint embellished another memorable movie moment. Actress Shirley Eaton was covered in gold paint for a short scene in the 1964 James Bond film *Goldfinger*. At the time, it was thought that humans breathed, in part, through their skin, so precautions were taken to leave areas of Eaton's body paint-free. Rumors that the actress died as a result of skin suffocation existed for many years. In 2018 the seventy-eight-year-old Eaton agreed to have her body painted gold again for a feature story in *Us* magazine, reassuring all that she was indeed alive and well.

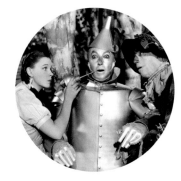

blue-chip stocks

TO SAY THAT AN investment, a stock, or a company is "blue chip" means that it is of the highest quality. The term comes from the game of poker, where small disks (called "tokens" or "chips") are used to represent money. Early versions of poker chips had the following values: white = $1, red = $5, and blue = $25. The blue chip, therefore, was the token with the greatest value. The expression emerged during the 1920s when a Dow Jones employee, in response to seeing stocks trade at the very high value of $200 to $250 per share, said he was going to "write about these blue-chip stocks." It is also worth noting that blue is a popular color in corporate branding. It is considered a conservative color, one that represents stability and reliability. Many financial and law firms incorporate blue into their branding to portray a sense of security. In other words, blue is a safe bet.

house paint names

HAVE YOU EVER STOPPED to read the names of the colors on paint chip samples? My personal favorites are Lettuce Alone (light mint green) and Grandma's Refrigerator (golden yellow). These two examples are the work of paint namers, who conceive hundreds of new names each year. Yes, paint names are important for an efficient coding system, but this exercise is primarily about marketing. Will a particular color name resonate with consumers? Will it spur a fond memory? Does Grandma's Refrigerator yellow remind you of your own grandma and the good times you had with her? A provocative name has the potential to tap into your emotions—whether you are aware of it or not.

However, there is more happening here than meets the eye. Within the paint industry, no two colors can have the same name. Paint companies refer to a comprehensive database of all existing paint names, from all paint manufacturers, to confirm that a proposed moniker is indeed unique and copyrightable. This explains why the names used to sell paint are becoming more and more innovative.

Below is a list of options that I've collected for lemony-yellow-colored paint. These are actual product names. Every paint company has a lemony yellow on its roster, but only one can be called Lemon Yellow.

Lemon Peel	Lemon Pepper	Sour Lemon
Lemon Wedge	Lemon Twist	Luscious Lemon
Lemon Slice	Lemon Spritz	Clear Lemon
Lemon Tart	Lemon Zest	Brite Lemon
Lemon Chiffon	Lemon Chill	Dark Lemon
Lemon Chiffon Pie	Lemon Balm	Minted Lemon
Lemon Meringue	Lemon Dew	Green Lemon
Lemon Mousse	Lemon Rose	Limey Lemon
Lemon Gelato	Lemon Burst	Lemonade
Lemon Sorbet	Lemon Wisp	Chilled Lemonade
Lemon Parfait	Lemon Lift	Icy Lemonade
Lemon Punch	Lemon Mimic	Cool Lemonade
Lemon Drop	Yellow Lemon	Fresh Lemonade
Lemon Ice	Fresh Lemon	Lemony
Lemon Butter	Cool Lemon	Hint of Lemon
Lemon Whip	Iced Lemon	Limone
Lemon Sugar	Washed Lemon	
Lemon Thyme	Bitter Lemon	

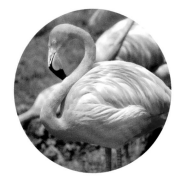

pink flamingos

WHEN MY NEPHEW WAS an infant, he paid a visit to the doctor. My sister was worried he was showing signs of jaundice. His yellowish hue, it turned out, was the result of a diet that consisted primarily of sweet potatoes, carrots, and squash.

Flamingos are pink for the exact same reason. It has to do with what they eat. This cartoonish creature can range in color from pale pink to vivid orange-red. Its unique diet, consisting of algae and small animals such as insect larvae, mollusks, and shrimp, is where it all begins. The beta-carotene in these foods, once digested, turns to pink or orange. The more a bird's diet is dominated by the distinct pigments of the carotenoids, the richer its color will be. Flamingos start out life covered in a light gray plumage and become more colorful as they mature. We humans age the other way around.

tartan
patterns

TARTANS ARE PATTERNS CREATED by intersecting vertical and horizontal lines of varying widths and colors. These patterns denote districts and clans and were originally produced from local natural dyes to help distinguish one region or family from another. Although they are primarily associated with Scotland, similar woven patterns have been used by other cultures—including in Austria, China, and Scandinavia.

There are three distinct color categories to consider when designing tartan variations: modern, ancient, and muted. Modern tartans are produced strictly from synthetic dyes. Ancient tartans make use of lighter shades, replicating a faded effect that would have occurred over time. And muted tartans have colors that fall somewhere in between the first two categories and attempt to re-create, with synthetic dyes, the colors achieved through natural dyes.

Currently, there are between three thousand and thirty-five hundred unique tartan patterns. This does not include the many variants of each design. It is estimated that more than 150 new tartan designs are created each year.

white wedding dress

WHEN YOU HEAR THE words *wedding dress*, I'll bet you imagine an elegant, flowing gown. A white gown. However, it wasn't until 1840 that white became fashionable for brides to wear on their wedding day. That was the year England's Queen Victoria married her first cousin Prince Albert. On that special day, she wore a white satin and lace dress trimmed with orange-colored blossoms. Her eighteen-foot-long train and satin slippers were also white. The dress captured the fancy of the public, and before long it became a worldwide sensation. Little did Queen Victoria know that she was establishing a new trend, one that is still prevalent. Several years after the royal wedding, *Godey's Lady's Book*, considered to be the voice of style in Victorian times, mistakenly stated, "Custom has decided, from the earliest ages, that white is the most fitting hue, whatever may be the material. It is an emblem of the purity and innocence of girlhood, and the unsullied heart she now yields to the chosen one."

Prior to the Victorian era, brides typically wore the best dress that they owned at the time of the marriage. Emphasis was on wealth and style, not necessarily color. There was a time when the color of choice was black, because it didn't show stains and could be worn again for a variety of occasions. Blue, with its association with purity, faithfulness, and the Virgin Mary, was also once a popular choice. But it was never as widely embraced as white would come to be. During the late 1800s, a pure white dress was a luxury, as bleaching fabrics was tricky and expensive. White wedding dresses of the period tended to be more ivory or ecru in tone.

Although white dresses are favored by many brides, they're not for everyone. In India and China, red is a popular choice. You will see yellow at Moroccan weddings, green at some Italian ceremonies, and purple in Eritrea.

seating arrangements

HAVE YOU NOTICED THAT the color red is prominent inside many movie theaters? Arguably, rich red seats and curtains add a certain sophistication to a venue, but the reason for the color choice goes deeper. It just so happens that human eyes are less sensitive to a deep shade of red, and this helps make the space appear darker when the lights go down, which makes viewing the movie screen easier.

Lately, though, there has been a trend toward installing multicolored seating in auditoriums that are used in both lit and unlit situations. In university lecture halls and sports facilities, colorful seating makes the space feel more energetic and friendly even when unoccupied. Some auditoriums even incorporate two different colors within each seat. This design feature gives personality to an empty room, making the environment more inviting. This is a good example of how interior designers are using color to humanize spaces that too often default to institutional banality.

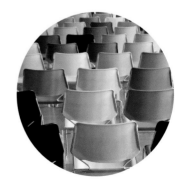

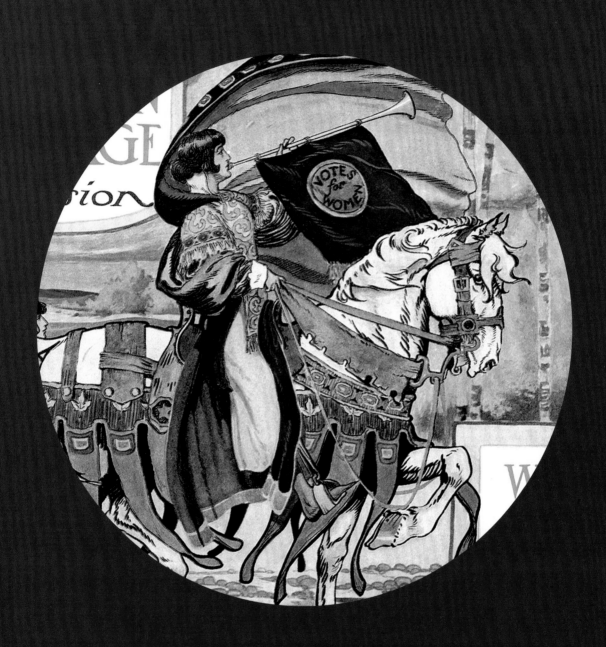

purple:
a noble cause

It's a hot summer day, and in the distance the sound of a lone bagpiper can be heard reverberating off the stone facades of Edinburgh's Old Town buildings.

 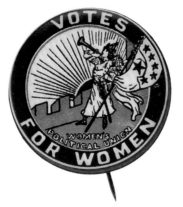

The distinctive skirl of the ancient instrument draws closer, and a growing swell of fervent voices joins the din. Thousands of women are marching through the streets of Scotland's capital to celebrate the one hundredth anniversary of winning the right to vote. Leading the march is a female piper wearing a kilt of tartan woven in purple, green, and white. On this particular day, June 10, 2018, all of the participants are proudly sporting one or more of these colors.

One hundred and ten years earlier, the British suffragette movement, under the leadership of Emmeline Pankhurst, organized a similar demonstration in London. Women's suffrage had been gaining momentum for years. At times, however, the journey became complicated by internal disagreements and a lack of focus. In 1908, Emmeline Pethick-Lawrence, the editor of the weekly publication *Votes for Women*, introduced the idea of branding the movement by using color. She explained her choices: "Purple, as everyone knows, is the royal

color, it stands for the royal blood that flows in the veins of every suffragette, the instinct of freedom and dignity. . . . White stands for purity in private and public life. . . . Green is the color of hope and the emblem of spring." To put this idea into practice, women proudly wore stylish clothing in the distinctive palette. On the day of the rally, more than thirty-thousand women descended upon Hyde Park, turning it into a sea of purple, green, and white. Tricolored banners, ribbons, scarves, and badges were everywhere. The idea had worked. The purple, green, and white palette became the official symbol of the women's suffrage movement.

In 1915, on the opposite side of the Atlantic Ocean, eight thousand women marched in Washington, D.C., for the same cause. At the front of the parade a banner proclaimed, "We demand a Constitutional amendment enfranchising women." On this occasion the activists wore purple and gold sashes. The American suffragists adopted purple

from their British allies but substituted gold for green to symbolize enlightenment, giving their movement a unique American flare.

In the 1960s, a second wave of feminism surfaced in the United States through the determination of groups like the National Organization for Women (NOW). And in 1978, a hundred thousand women marched in Washington, D.C. Once again, Pennsylvania Avenue was teeming with shades of purple, gold, and white. Currently, both NOW and International Women's Day have purple logos.

Demonstrations in support of women's rights were instrumental in appropriating purple as the color of women's causes. They employed no logo, no insignia, not even an overarching rallying cry. Color alone did the heavy lifting. Suffragettes chose purple because of its encoded meaning. For centuries it was the color that people of power wore—emperors, priests, magistrates, and warriors. Purple became synonymous with ambition, dignity, and independence. Christianity uses it to represent pride. In America, the Purple Heart is awarded to soldiers for courage and bravery. In China, it symbolizes immortality.

The suffragettes chose wisely when they selected purple, with its impressive list of noble attributes, to help champion their cause.

indelible ink

DO YOU REMEMBER RECEIVING tests or papers back from your teachers? Anticipating your grade and sifting through the comments scrawled in the margins could be stressful. Recent studies suggest that there may have been something else adding to our anxiety—the color of the ink used by the teacher.

It appears that red ink has a way of stirring up a wealth of emotions. Research conducted by sociologists at the University of Colorado indicated that the color red is associated with warning, anger, caution, and embarrassment. The researchers concluded that using a red pen can heighten negativity and have an adverse effect on a teacher-student relationship.

In response to these findings, some schools in the United States and Great Britain are banning the use of red ink for marking and grading. The recommendation is to use a more neutral shade. Green, a positive color, is a good alternative.

Experts are not all in agreement with the study's finding, and some feel further research is required. However, as researcher John Grohol of PsychCentral said, "When in doubt, it's probably best to leave your creative red side be and grade papers in a neutral color. That seems to be the safest choice, if one doesn't want to accidentally say more than they had intended."

tiffany blue

IN 1845, TIFFANY & CO., the "stationery and fancy goods emporium," produced its very first catalog highlighting its collection of luxury merchandise. Charles Lewis Tiffany, one of the company's founders, chose a light robin's-egg blue for the cover of the publication. The color turquoise was in vogue at the time. It was made fashionable, in part, by Victorian brides who presented their bridesmaids with gifts of jewelry made with the semiprecious gemstone.

The icy-blue color immediately resonated with the public, probably as a result of the color's positive association with blue skies and tropical oceans. The Pantone Color Institute created a custom blue for Tiffany: PMS 1837. The number corresponds with the year the company was founded. This unique shade of blue is now synonymous with the company, making it one of the few brands that people are able to identify through color alone.

cleveland browns

THE HELMETS OF SOME football teams are emblazoned with eagles, buffalo, horseshoes, stars, or Vikings. But one National Football League team has no logo: the Cleveland Browns of the AFC North Division. When they run onto the gridiron, they wear orange helmets with no icon, no crest, no letters—nothing. How does a major-league sports franchise not have a team logo? And why are they emphasizing the color orange?

For thirty-five years the Cleveland Browns boasted that their team was named after legendary boxer Joe Louis, whose nickname was the Brown Bomber. The organization wanted to be associated with a winner, and Joe Louis, the world heavyweight boxing champion from 1937 to 1949, fit the bill. The thing is, the story was completely made up. In fact, the team was named after its first coach—Paul Brown. After rejecting the name Cleveland Panthers, picked through a fan contest, owner Mickey McBride decided his football team would be named after the coach. Paul Brown was extremely uncomfortable with this decision and invented the Brown Bomber story to deflect attention away from himself. Perhaps this awkward history explains why the Cleveland Browns choose not to have a logo. If only they could get the color of the helmet right.

cleaner shrimp

WHEN YOUR CAR GETS dirty, you take it to a car wash. But what happens if you're a fish and you get dirty? You pay a visit to a cleaner shrimp. And if style is your thing, you visit a *Lysmata debelius*, or fire shrimp. This cleaning machine comes in a bright red finish, accented with white polka dots, and sports three pairs of white legs and six white antennae. Fire shrimp set up shop at coral reefs and provide their cleaning service to patiently waiting fish, who will line up to be detailed. The shrimp benefit from the many nutrients they eat off the surface of their clientele, and the fish are cleaned of parasites and dead tissue. It's coexistence at its best.

Research has shown that a special code exists between the two sea creatures. The shrimp wiggle their antennae to let the fish know they are open for business, and the fish turn a darker color to signal their willingness to be cleaned. When it comes to advertising, using the color red is always an effective way of attracting attention.

word origins

aubergine

oh-ber-jeen / French / 1794

Aubergine is the French word for "eggplant." The white-colored variety of eggplant gave the vegetable its English name due to its resemblance to an egg. However, most of us are familiar with dark purple eggplant. *Aubergine* refers to this color. The word is also a diminutive of *auberge,* which in turn comes from the Spanish word *alberge,* meaning "peach."

magenta

muh-jen-tuh / Italian / 1857

Magenta is the name of a town in northern Italy. In 1859, during the Second Italian War of Independence, the Battle of Magenta occurred. This bloody battle resulted in seven thousand casualties, all of whom were buried in one mass grave. Not long afterward, a new purple-pink dye was developed, and it was named magenta in honor of that significant victory.

chartreuse

shahr-trooz / French / 1865–1870

Since 1737 the Carthusian monks of France have been producing the yellowy-green liqueur Chartreuse, which is made from 130 different flowers, plants, and herbs. Chartreuse, a French word for "charterhouse," is named after the monk's Grande Chartreuse monastery in Grenoble, France. It wasn't until 1884 that the word *chartreuse* became generally used to describe this unique color.

colorado

kol-uh-rad-oh / Spanish / 1861

This American state was named for the Colorado River—or, in Spanish, Rio Colorado. The translation literally means "reddish-colored river." It's the iron ore found in many Colorado mountains that, in certain locations, tints the water red.

beach sand

PEOPLE LOVE LOUNGING AND playing on a beach. The sand feels soft and warm, it molds nicely to your body when you're sunbathing, and it often harbors interesting treasures. But what exactly is a beach made of? The natural materials native to each locale help create the texture and color of the sand. Most beach sand consists primarily of calcium carbonate, a by-product of shells and decomposed marine organisms. Raw materials such as coral, mollusks, and microorganisms add to the mélange. Weather, time, and the persistent pounding of ocean waves contribute to the surfaces of these tactile waterfront carpets.

A typical beach has an overall light ecru coloring, resulting from many sun-bleached elements. But many different colors of beach sand are found throughout the world. Let's go traveling and visit a few. Pink beaches, found in the Caribbean, Greece, and Spain, are heavy with foraminifera, microscopic organisms with a reddish pink shell. Foraminifera are neither an animal nor a plant. They are classified as a protist, a single-celled creature that lives inside other shells. Black sand beaches, like the ones in Hawaii, are composed of volcanic minerals and lava fragments. At Pfeiffer Beach in California, one can enjoy purple sand whose unique hue comes from particles of glass-like garnet. Norway's Lake Hornindalsvatnet is one of the few places on the planet that boasts a green beach. Olivine crystals are at work here, getting their olive green color from ferrous iron. Perhaps the strangest component of a beach is found on Hawaii's white sand beaches. Their famous pristine white sands are made from—are you ready for it?—parrotfish poop. Be sure to use the beach shower before you head home.

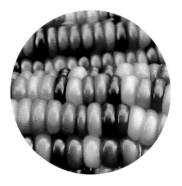

glass gem corn

HEIRLOOM GARDENING CONTINUES TO attract interest throughout the world as a way of reintroducing ancient varieties of vegetables and fruit. In recent years a variety of heirloom corn known as Glass Gem has caused quite a stir. This colorful strain of flint corn has a jewel-like quality that makes it both unique and highly appealing. Flint corn, although edible, is not sweet and is typically used to make flour or popping corn.

Carl "White Eagle" Barnes, a part-Cherokee farmer from Oklahoma, worked hard during his lifetime to amass and preserve hundreds of varieties of rare maize. He was especially interested in collecting ancient seeds from Native American tribes—in particular, species that produce colorful ears of corn. Glass Gem is a special blend of Pawnee miniature corn varieties, Osage red flour corn, and Osage Greyhorse corn. In 2010 this bedazzling heirloom corn became available to the public through Native Seeds/SEARCH, a Tucson, Arizona–based nonprofit conservation organization. Their website sums it up best: "As eye-popping images of Glass Gem continue to spread around the world, Carl Barnes's kaleidoscopic corn has become a beacon—and perhaps an inspiring symbol—for the global seed-saving revival."

LIFE

HEALING

SUNLIGHT

NATURE

HARMONY

SPIRIT

pride flag

YOU KNOW YOU'VE CREATED a classic icon when it becomes part of the Museum of Modern Art's (MoMA) permanent design collection. In 2015 the pride flag, or rainbow flag, which is a symbol for the LBGTQ+ community, joined the ranks of the Slinky, Volkswagen Beetle, iMac, and I Love New York logo.

Since its debut in the 1970s, the rainbow flag has flown in a variety of configurations. It is generally believed that the flag has its roots in a flag that was popularized with world peace marches on American university campuses during the 1960s. That flag was made of five horizontal bands of color said to represent the major skin pigments found throughout the world: red, white, brown, yellow, and black.

The rainbow flag, designed by artist Gilbert Baker, first flew at a Gay Freedom Day Parade in San Francisco in 1978. The flag originally consisted of eight stripes. Besides what you see in the pictured flag, it included a pink stripe (for sex), and two stripes took the place of navy—turquoise (for magic/art) and indigo (for serenity).

Other colors have been incorporated into the flag design over the years. For a short while, black was added to the mix to symbolize the AIDS crisis. Some versions introduced a white stripe to represent peace and unity. Philadelphia added black and brown stripes to the classic six-stripe flag in 2017 to acknowledge people of African and Latino descent. Lavender is sometimes included, symbolizing diversity. However, it is the internationally recognized six-stripe version that sits in the MoMA collection, proving, once again, that colors can embody and communicate a powerful message.

capuchin
friars

RELIGIOUS HABITS SAY A lot about the people who wear them. The quality of the materials, degree of embellishment, use of iconography, and color all reflect a certain role or hierarchy within a given faith. A friar's robe has always been a humble garment, designed to be both understated and functional. The habit worn by the Catholic Church's Order of Friars Minor Capuchin is no exception.

The origin of the robe goes back to the 1500s, when certain friars broke away from the Franciscan order to adopt a more primitive lifestyle. The common brown fabric used to make their robes was donated by local residents. These friars slept on dirt floors, and the color of their robes disguised the resulting mess. The Capuchin friars soon became instantly recognizable by their vestments' long pointed hoods, called "capuches," which fell down the length of their backs.

That characteristic brown hood has had an impact beyond the monastic brotherhood. It was the inspiration for the naming of capuchin monkeys, which appear to be wearing brownish caps. And somewhere along the line, someone found the appearance of an espresso with milk to also be reminiscent of a friar's garb. That is why the beverage is called "cappuccino." It seems ironic that the robe worn by a fraternity of down-to-earth Italian devotees should influence the name of an expensive, upscale coffeehouse brew.

little red book

THE LITTLE RED BOOK debuted in 1964. Known for its bright red cover, the publication was available in thirty-two different sizes—the most popular being a pocket-size version. The official name of the book is *Quotations from Chairman Mao Tse-tung*. Mao was the leader of the Communist Party of China from 1935 until his death in 1976. Filled with excerpts from Chairman Mao's speeches and writings, the book includes subjects as diverse as class struggle, war and peace, patriotism, and relationships between the army and the people. All Chinese citizens were expected to own a copy of the book, and most saw it as a form of protection during the controversial social-political Cultural Revolution (1966–1976). It's estimated that over one billion copies have been produced.

Red is a powerful color, one that China has a long history of embracing. Several early Chinese emperors followed the theory of the Five Elements (wood, fire, earth, metal, and water) and used their individual color associations to promote their dynasties. Red is the color of fire, an element that evokes warmth, aggression, passion, and joy. For Chairman Mao, red was the color of the Communist Revolution, symbolizing the blood shed for the cause. In 1949, China adopted its current flag, the red rectangle with yellow stars, and red became the color of the nation—its people and the government. No wonder the Little Red Book is so iconic; the color alone is rich with meaning.

tulip fields

IF YOU VISIT THE Netherlands in the springtime, one thing will quickly become apparent: It's tulip-growing season. Every spring, rows upon rows of the national flower carpet regions of the country with shocks of vibrant color. Holland allocates approximately 29,500 acres of farmland to tulips—the equivalent area of two Manhattan Islands.

It is a little known fact that tulips continue to grow after they are cut, a feature that makes the popular blooms ideal for shipping long distances. And Holland exports upward of three billion flowers each year, in every imaginable color, including black. Over time, the flower's colors have come to represent a range of different emotions or sentiments. Red is for love, white for forgiveness, orange for happiness, yellow for hope, and pink for confidence. These associations are not common to all varieties of flowers; nuances exist depending on the bloom.

Believe it or not, the tulip is not originally from Holland. Its roots are in Turkey and date back to the Ottoman Empire. The word *tulip* emerged in the 1550s and is derived from the Persian word for "turban" due to the flower's resemblance to a man's headdress.

In 1637, at the peak of the tulip's desirability, bulbs were such a sought-after status symbol that people paid outrageous sums of money for them. One unique specimen, the Semper Augustus, fetched the most money of them all—more than 10,000 guilders for a single bulb. To put that into perspective, a stately home on a fashionable Amsterdam canal during that period cost the same amount.

Tulips remain a perennial favorite. Thousands of enthusiasts make the pilgrimage to the "flower shop of the world" each spring to witness the blooming of this simple yet elegant flower.

baker-miller
pink

THE VISITORS' LOCKER ROOM at the University of Iowa's Kinnick Stadium is pink—floor-to-ceiling bubble-gum pink. In 1979 the incoming head coach of the Iowa Hawkeyes football team, Hayden Fry, had the room pink-washed. He had heard the color made people passive and wanted to unnerve visiting football teams by emasculating them. Pink, said Fry, was a "sissy color." In 2005, when the stadium underwent renovations, not only did the locker room remain pink, but it was also enhanced with the addition of pink sinks, urinals, and lockers. When questioned about the appropriateness of this tactic, the university's official stance is that it represents a tradition, all done in good fun. Not surprisingly, others disagree. According to Minnesota attorney Jill Gaulding, a former professor at Iowa, "It's not okay for them to put up a banner that says it's bad to be a girl. It's not okay for them to build a pink locker room that conveys that same idea." She and others believe the locker room itself is a sexist or homophobic slur.

Also in 1979, a paint color known as Baker-Miller pink was created with the claim that it would noticeably diminish aggressive behavior. It was developed for a naval correctional institute in Seattle to study the impact of pink prison cells on prisoners. (The paint name comes from the institute's directors at the time, Baker and Miller.) A follow-up report stated that, "since the initiation of this procedure on 1 March 1979, there have been no incidents of erratic or hostile behavior during the initial phase of confinement."

Baker-Miller pink has gone on to adorn prison cells, psychiatric wards, youth clinics, and drunk tanks. Subsequent studies have shown that the calming effect only lasts for fifteen to thirty minutes. The Maricopa County Jail in Arizona had quite a different experience with their pink cells. Their inmates grew noticeably more aggressive when confined to these environments for extended periods of time. The jail was quick to switch to an alternative solution: They repainted the cells a different color and made the prisoners wear pink underwear.

green:
home truths

Color and danger share a close relationship. Red alerts us to precarious railway crossings or increased risk of forest fires or terrorist threats.

Yellow flags on a racetrack caution drivers against an accident or hazardous conditions. In the animal kingdom, brightly colored frogs and boldly striped skunks signal danger to their predators. But is it possible for a color itself to be dangerous?

For a period of fifty years, between 1820 and 1870, Victorian Britain experienced an unprecedented infatuation with nature. "By the middle of the century," says Lynn Barber in her book *The Heyday of Natural History*, "there was hardly a middle-class drawing room in the country that did not contain an aquarium, a fern case, a butterfly cabinet, a seaweed album, a shell collection, or some other evidence of a taste for natural history." People combed the countryside and seashore for specimens to augment their personal displays. An affinity for nature confirmed an individual's curiosity for the growing disciplines of science and the intellectual discourse they spawned.

Interior decorators of the day championed this phenomenon by introducing nature-inspired design elements. Organic shapes found their way into the design of wicker chairs and cast-iron table bases. Upholstery and area carpets adopted intricate weaves of flowing leaves and plants. Probably one of the most popular decor items for the Victorian home, wallpaper, offered up floral motifs of all descriptions.

Wallpaper was available in a vast array of lustrous shades of green. Inspired by new-growth moss, maidenhair ferns, and marsh grasses, these verdant hues helped bring the outdoors inside. To achieve these vivid colors, craftsmen experimented with a range of dyes and ingredients. Manufacturers were forever trying to outdo one another by creating new, more alluring variations of green. The pigment that people coveted the most was Scheele's Green. Its sumptuous apple green color injected life into parlors, dining rooms, and even bedrooms.

As an unbounded enthusiasm for the color took hold, something peculiar occurred within the homes of affluent Victorian families. People became sick. Initially, the cause was a mystery, but a relentless investigation conducted by a strong-willed physician eventually isolated the problem. The culprit was green wallpaper, specifically green flock wallpaper. Flock, a dustlike waste product from woolen cloth, was glued to the wallpaper, giving it a texture similar to velvet.

Scheele's Green, as it turns out, was laden with high levels of arsenic. People's lives were jeopardized by exposure to airborne flakes of the pigment or the toxic gases it emitted. For many years, British manufacturers had turned a blind eye to the dangers of arsenic, because it was the magic catalyst behind the success of their trendsetting product. Although the poisonous wallpaper did not affect every-one, the elderly and the very young were especially susceptible to its toxicity. Eventually, several deaths were traced to arsenic poisoning from the seemingly innocuous green wallpaper.

As the dangers of arsenic became more well known, the public demanded it be removed from a host of products. Besides wallpaper, the deadly ingredient was found in green glass, green paint, and the fashionable green clothing of the day.

People's appreciation for nature opened their minds to a larger world and larger concepts. Numerous discoveries in the sciences occurred during the Victorian era, with advancements made in astrology, physics, and medicine. And all the while, Charles Darwin, the great naturalist, was laying the foundation for the science of evolution. During this period, a generation became intoxicated with a natural color. Little did people know that the very thing adding beauty to their personal lives was also a thinly disguised killer.

harvard color library

THE HARVARD COLOR LIBRARY is officially known as the Straus Center for Conservation and Technical Studies. It is located at Harvard University in Cambridge, Massachusetts. Unlike the shelves in a conventional library, the shelves here are filled with a vast collection of color pigment samples, housed in all shapes and sizes of vessels. It all began with Edward Waldo Forbes (the grandson of Ralph Waldo Emerson and a Harvard graduate) and his fascination with fine art. Forbes's efforts to authenticate classic European paintings gave him a greater understanding of the technique of applying paint, which, in turn, encouraged him to systematically study pigments and art conservation.

The center's Forbes Pigment Collection consists of over 2,500 color samples amassed during Forbes's travels throughout the world. The collection, which continues to grow, is open to both the public and researchers and has been used in detailed paint analysis. In fact, the center helped detect a fake Jackson Pollock painting by determining that it used pigments manufactured after his death. The pigments in the collection come from a variety of sources, some of which are expected (such as plants and minerals) and others less so (like insects and the urine of a cow). Equally as captivating as the cabinets displaying the curiosities are the stories behind them. A perusal of the shelves reveals fanciful names with intriguing histories, custom colors manufactured for famous artists, and poisonous concoctions that were dangerous to work with. This absorbing collection reminds us that the myriad colors surrounding us in life each have their own tales to tell.

works cited

Boshart, Rod. "Kinnick Stadium's Pink Visitors Locker Room Gets Critical Look." *Quad Cities*, 4 April 2013.

"Chapter One: As Interesting as a Novel." *The Heyday of Natural History: 1820–1870*, by Lynn Barber, Cape, 1980.

Grohol, John. "Does a Red Pen Matter When Grading?" *PsychCentral*, 8 July 2013, psychcentral.com.

Irving, Washington. *History, Tales and Sketches ; Letters of Jonathan Oldstyle, Gent ; Salmagundi or The Whim-Whams and Opinions of Launcelot Langstaff, Esq & Others ; A History of New York from Beginning of the World to the End of the Dutch Dynasty ; The Sketch Book of Geoffrey Crayon, Gent.* Literary Classics of the United States, 1983.

"KFRC Radio Interview with John Lennon." 8 December 1980.

Krizanovich, Karen. "Suffragettes—The First Modern Campaigners." *The Telegraph*, October 2015.

Loewy, Raymond. *Industrial Design*. Overlook Press, 1979.

Muth, Felicity. "What Makes Bowerbirds Such Good Artists?" *Scientific American*, 7 January 2015, scientificamerican.com.

Obiria, Morra. "Farmers Discover Painting Chicken Purple Keeps Away Aerial Predators." *Daily Nation*, 17 March 2015.

Staff. "Techniques: The Passing of Mummy Brown." *Time*, 2 October 1964.

Staff. "The Story of Glass Gem Corn: Beauty, History, and Hope." *Native Seeds Search*, 10 June 2013, nativeseeds.org.

"Tales from the Dark Side: Has the Black Uniform Trend Finally Peaked?" *ABCNews*, 16 February 2017, abcnews.go.com.

Tsoulis-Rey, Alexa. "What It's Like to See 100 Million Colors." *The Cut*, 25 February 2015, thecut.com.

photo credits

acknowledgments

Firstly, I'd like to thank the following people who knowingly and unknowingly taught me invaluable lessons about color:

My mom, Janet Hambly.

My high school art teacher, Kay Boa.

My art school 2D instructor, Ron Dorfman.

The brilliant color theorist Josef Albers.

The master of light, Claude Monet.

Colorists Ben Nicholson and Stephen Shore.

Mother Nature.

This book would not have happened had it not been for Chronicle Books editor Bridget Watson Payne. If only she could have seen my face the day I opened her email offering to publish a print version of my *Colour Studies* blog. Thanks, Bridget. Editor Mirabelle Korn masterfully guided me through the process of pulling a book together with kindness and patience. The name Mirabelle comes from the Latin word for "wondrous"—need I say more? Allison Weiner's design is fresh and inviting. And, the two of us like circles.

Four generous individuals from Toronto—Nan Froman, Sarah MacLachlan, Matt Williams, and Dean Cooke—provided me with their professional advice and wisdom. My thanks to you all.

That leaves two people. My wife, Barb, and my daughter, Emma. You couldn't ask for two more supportive people. They deserve blue ribbons for their story suggestions, orange roses for their enthusiasm, and gold medals for putting up with me. This book is for you.